HANDS

A PICTORIAL ARCHIVE FROM NINETEENTH-CENTURY SOURCES

1166 Copyright-free Illustrations for
Artists and Designers

Selected by

JIM HARTER

DOVER PUBLICATIONS, INC.
New York

PUBLISHER'S NOTE

Wood engravings, with their crisp black-and-white lines, were popularized by Thomas Bewick at the end of the eighteenth century and quickly became the favored medium of mass reproduction of artwork in the nineteenth. While there were only about 20 wood engravers in the United States in 1838, by 1870 their number had swelled to about 400. Most of them earned their living by engraving illustrations for the great periodicals of the era, *Harper's Weekly* and *Leslie's Illustrated* foremost among them. With great skill the artists rendered sketches and photographs into precise illustrations. The medium admitted a wide variety of styles from simple, bold line drawings to those so carefully worked that the effect of gradation of tone was achieved, sometimes with an impressionistic feeling.

By the mid-1880s the means had become available for reproducing photographs as halftone illustrations, but they were both crude and expensive. It was not until the 1890s that the art of wood engraving began to be superseded by the new process. Ironically, now that the technique of the wood engraving has been largely lost, the popularity of these illustrations is reviving. Artists find the material widely adaptable to projects such as collage. Graphic designers are rediscovering how well the engravings complement typography.

Using his keen eye, artist Jim Harter has for this selection carefully drawn upon numerous books and periodicals, many difficult to locate, including *Chatterbox*, *Die Frau als Hausärztin*, *Illustrated London News*, *La Nature*, *Scientific American* and *Tom Tit*. The material reflects a range of different effects that could be achieved by wood engraving, as well as the diversity of the subject. A few engravings that predate the nineteenth century have been included by way of contrast.

Planned to be of maximum use to artists and designers, this collection reveals the expressiveness and loveliness of the human hand in an exceptional variety of contexts, including writing, sewing, demonstrating scientific experiments, using tools, performing magic tricks, applying first aid, playing parlor games and even casting hand shadows on the wall. Hands are displayed to demonstrate palmistry, anatomy and the deaf-mute language, or are simply poised to reveal their beauty or sturdy dignity. In response to the demand for hands with pointing fingers, a large selection of these in various types and sizes has been included.

Published in Canada by General Publishing Company, Ltd., 30 Lesmill Road, Don Mills, Toronto, Ontario.
Published in the United Kingdom by Constable and Company, Ltd.

Hands: A Pictorial Archive from Nineteenth-Century Sources is a new work, first published by Dover Publications, Inc., in 1985.

DOVER *Pictorial Archive* SERIES

Manufactured in the United States of America
Dover Publications, Inc., 31 East 2nd Street, Mineola, N.Y. 11501

Library of Congress Cataloging in Publication Data

Harter, Jim.
Hands : a pictorial archive from nineteenth-century sources.

(Dover pictorial archive series)
1. Hand in art. 2. Wood-engraving, American. 3. Wood-engraving—19th century—United States. I. Title. II. Series.
NE962.H35H37 1985 769'.42 85-12906
ISBN 0-486-24959-X

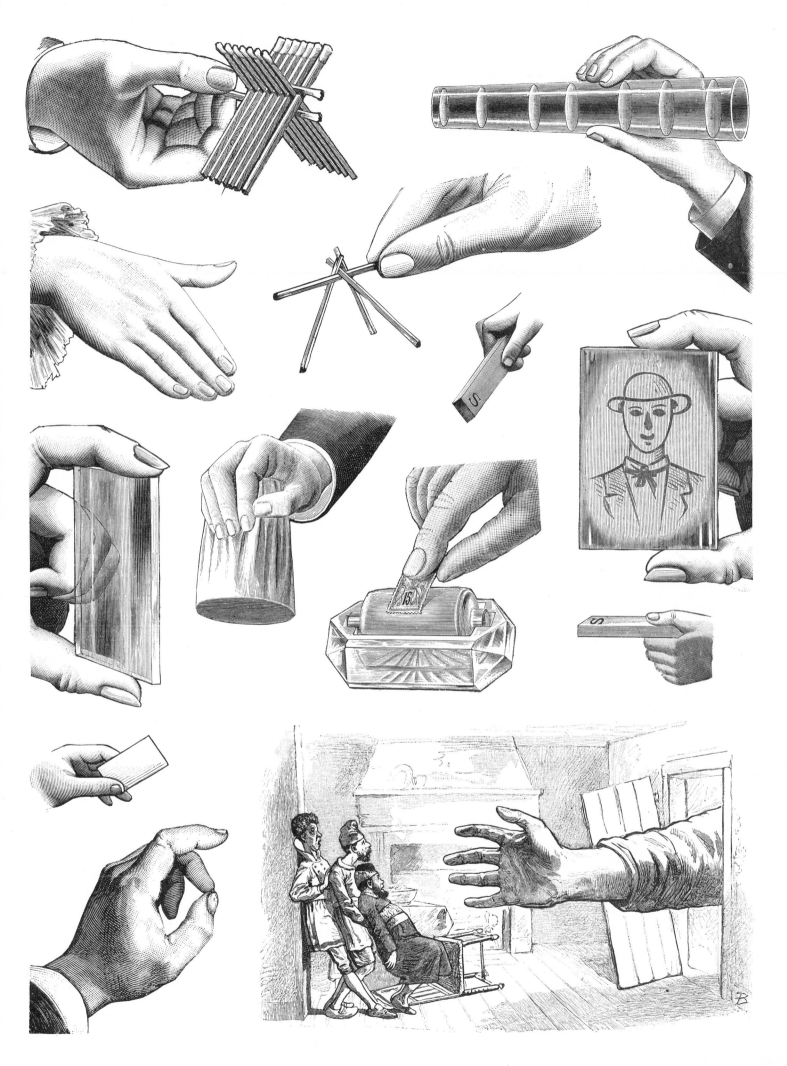

1

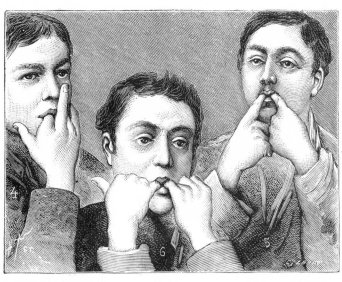

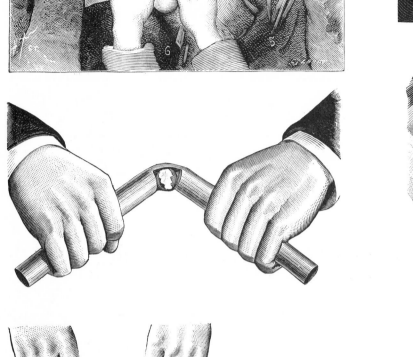

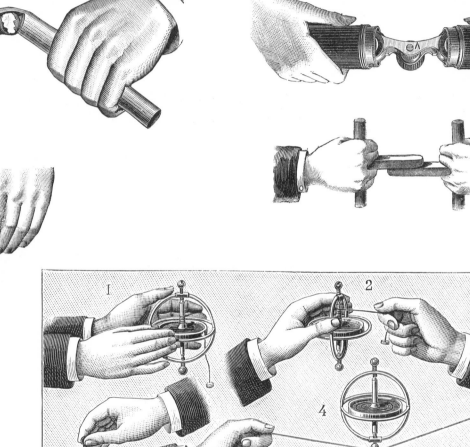

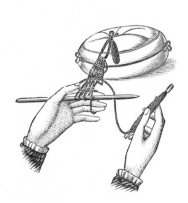

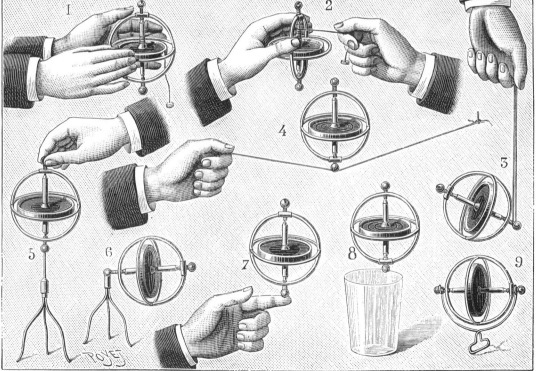

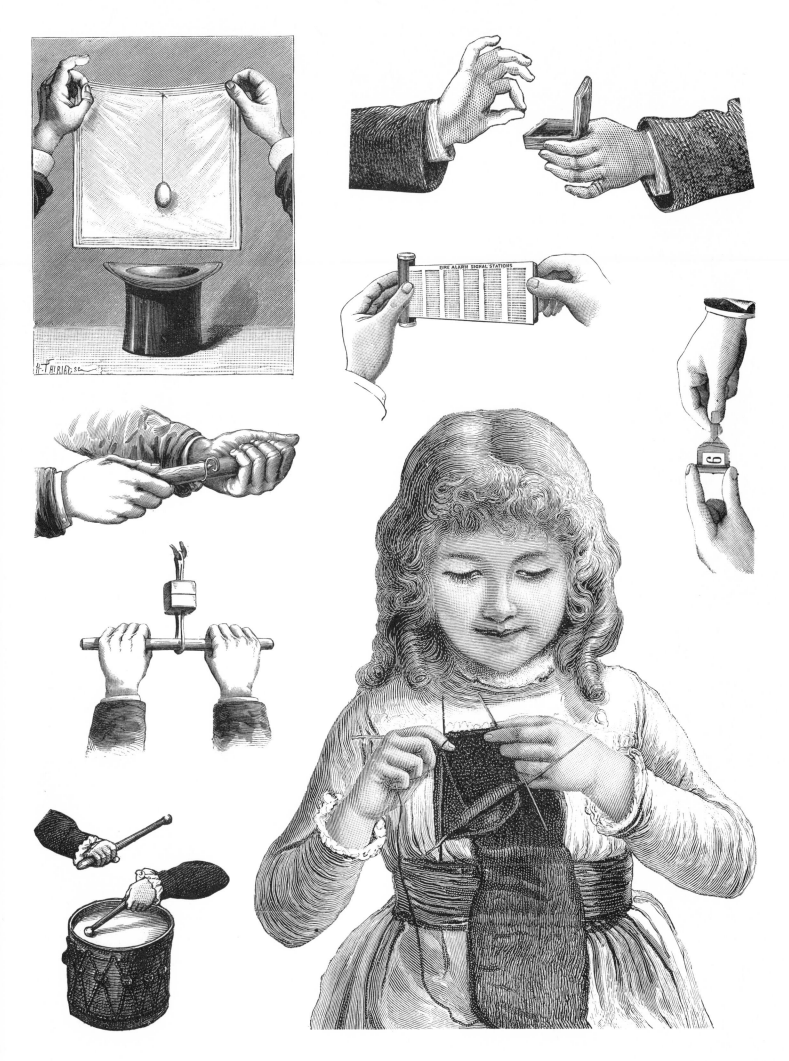

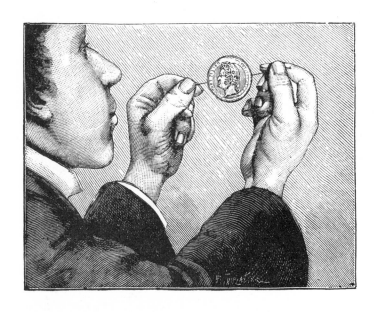

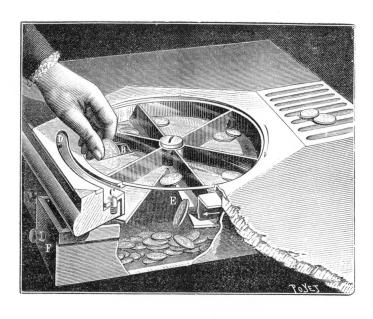

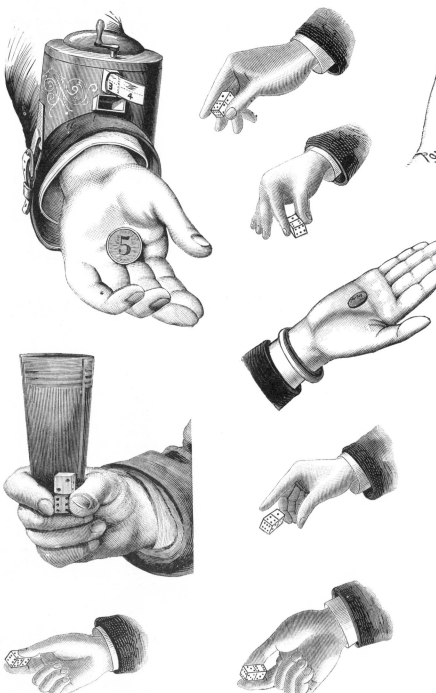

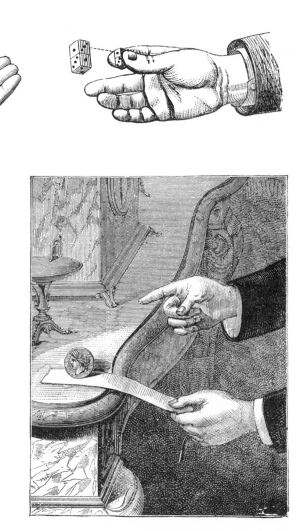

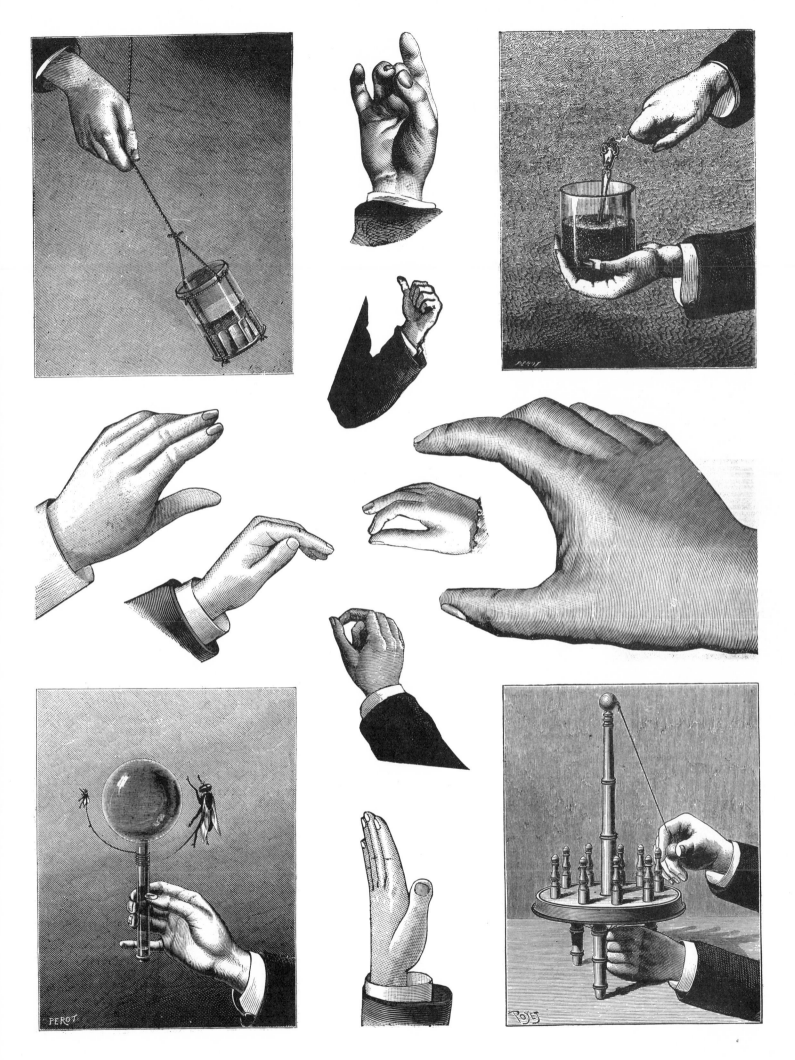

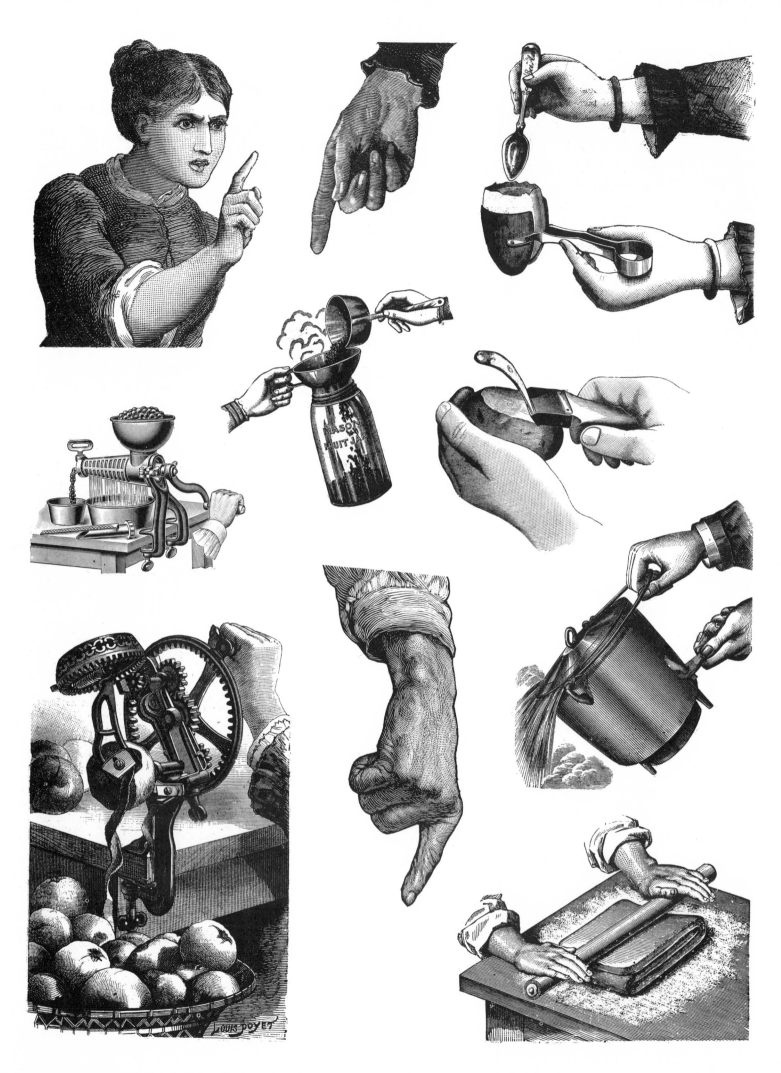

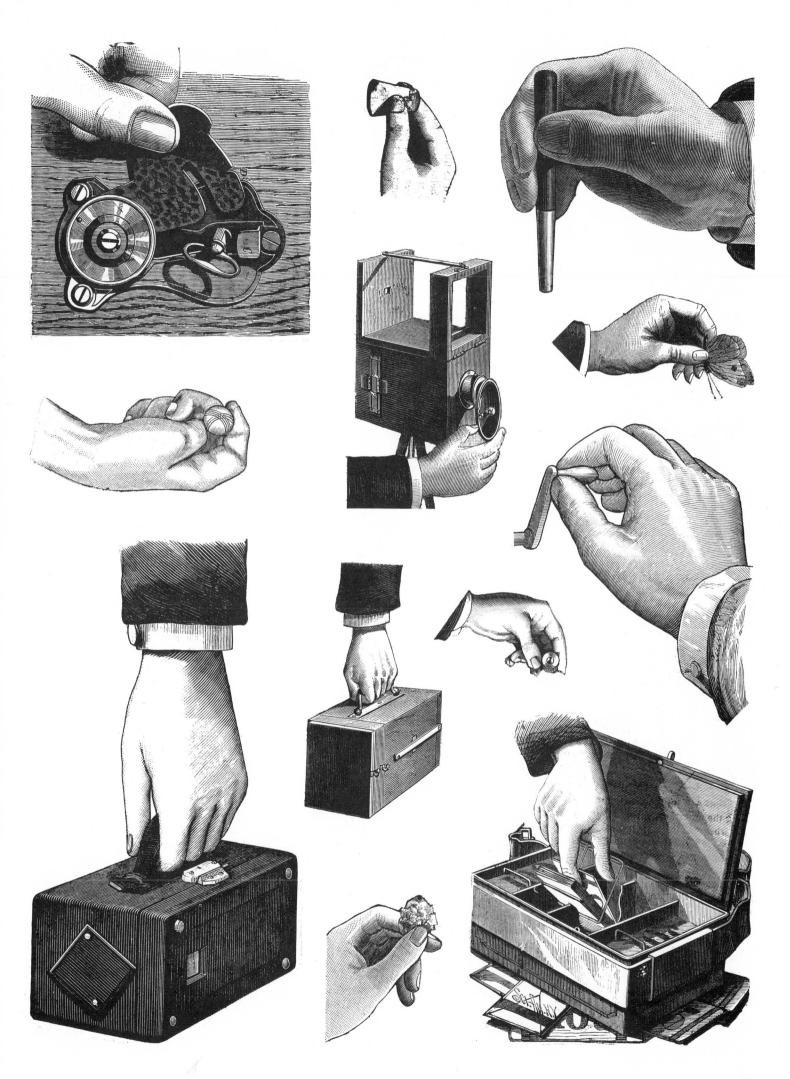

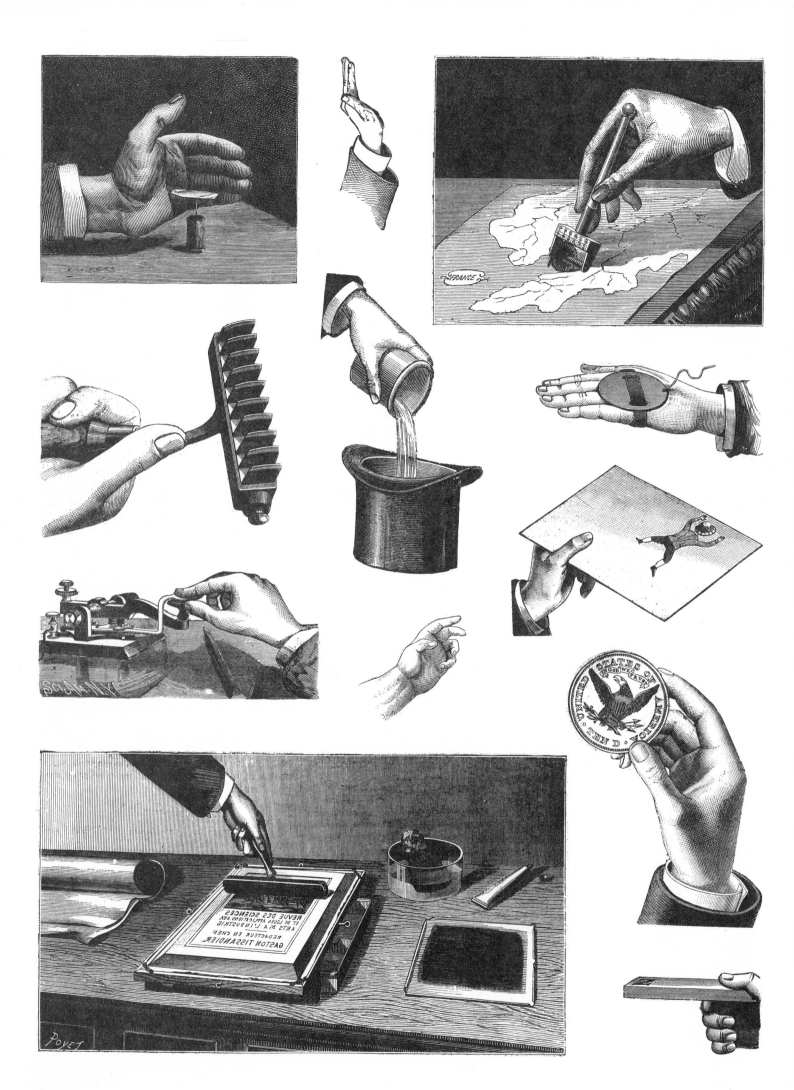

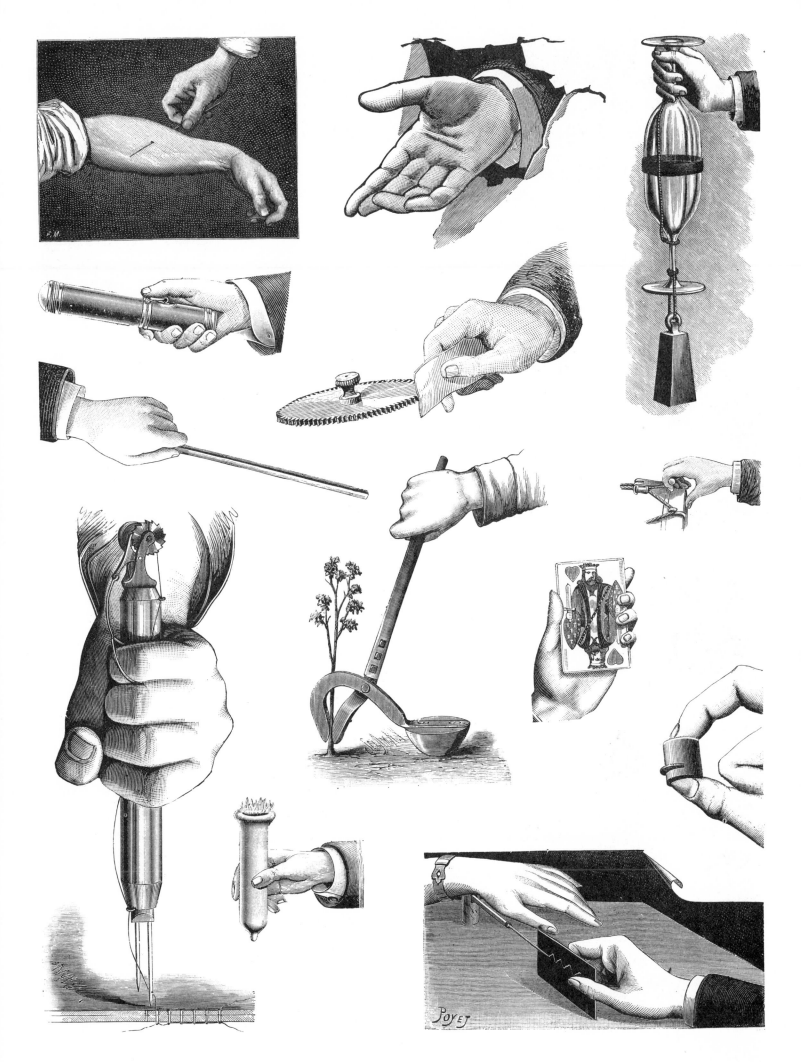

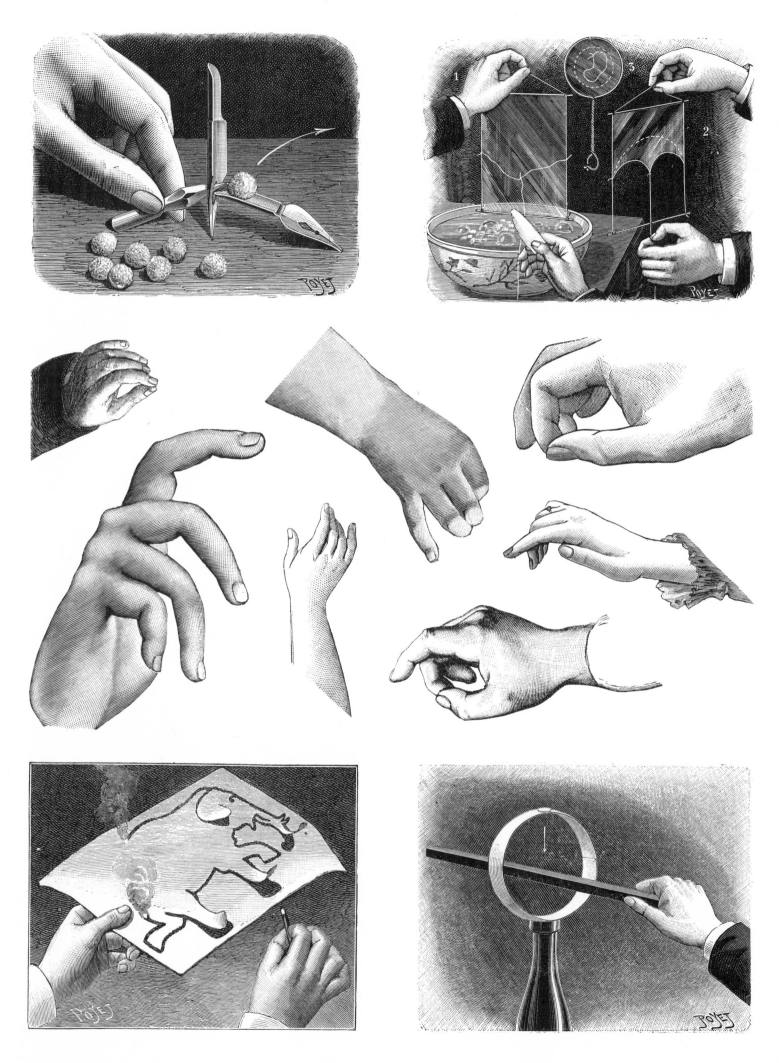

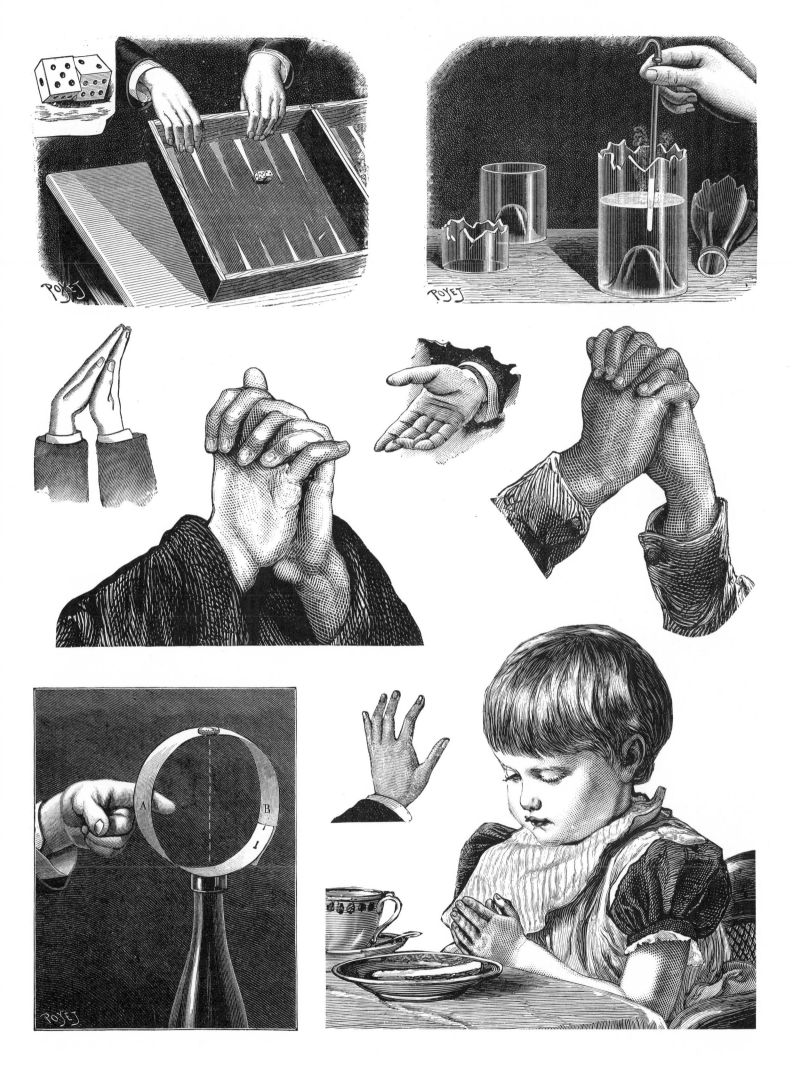

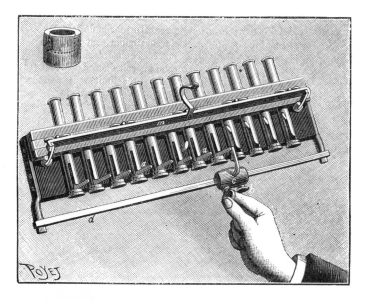

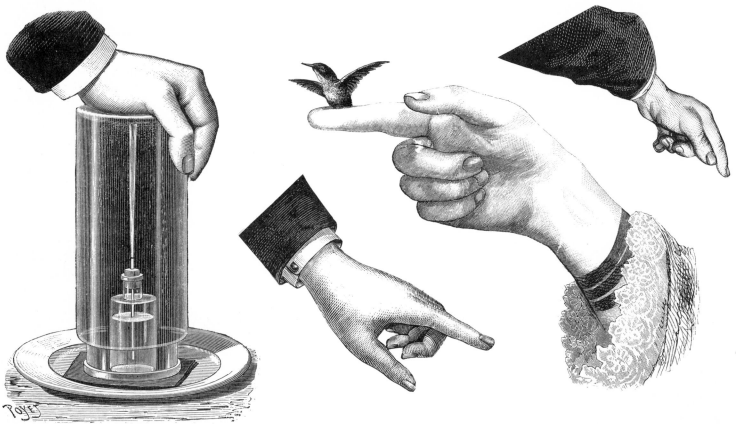

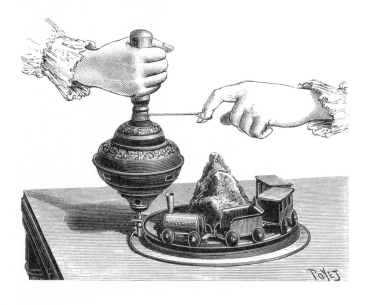

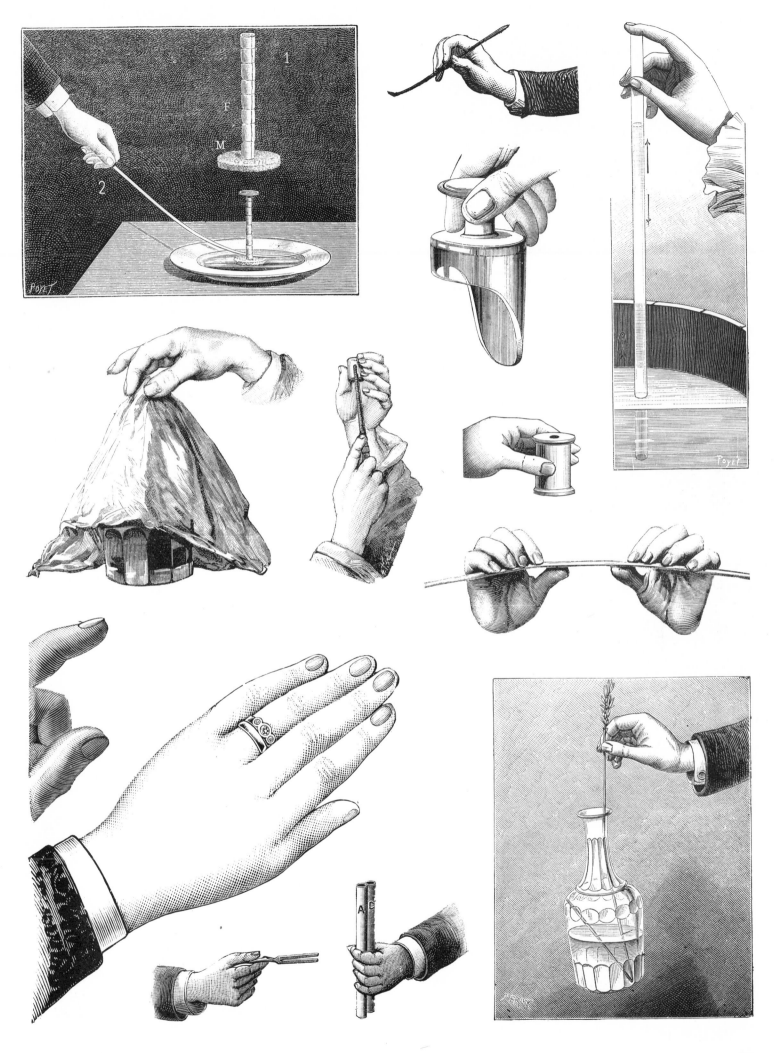

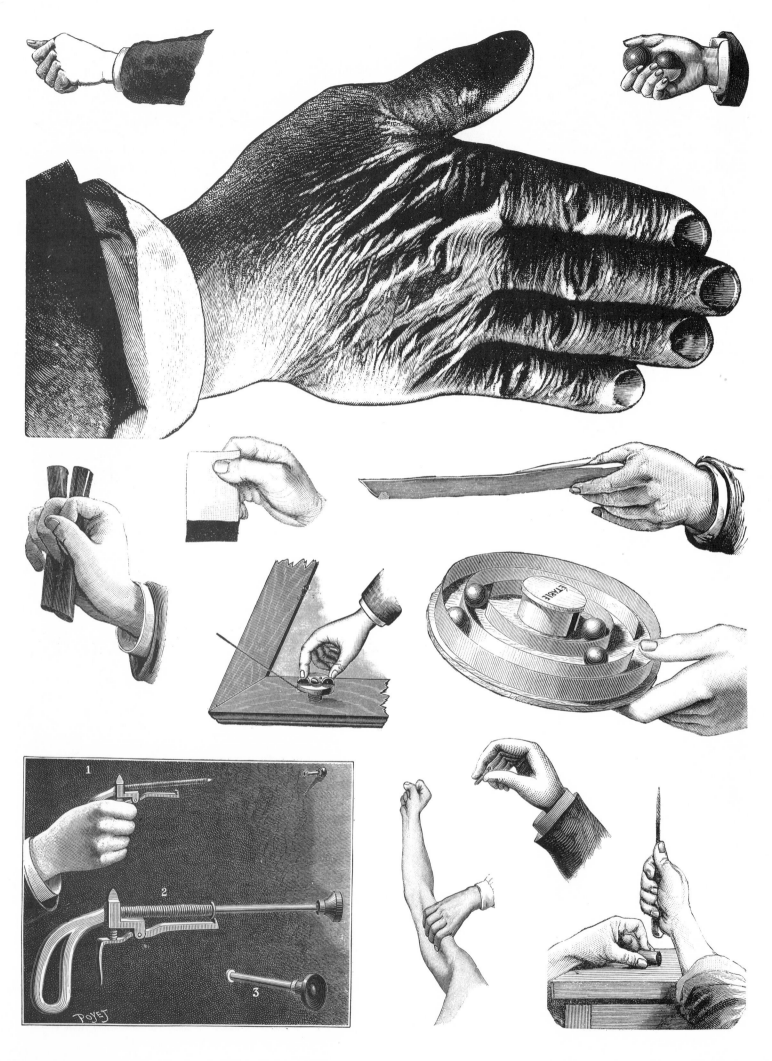

14

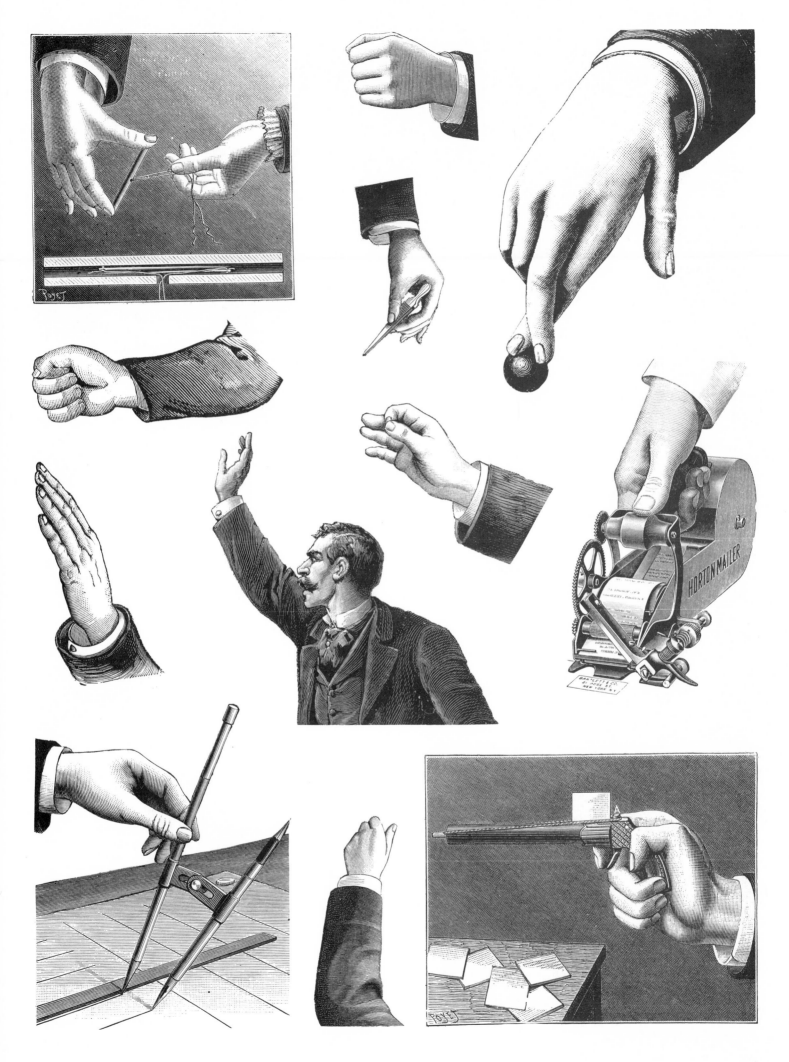

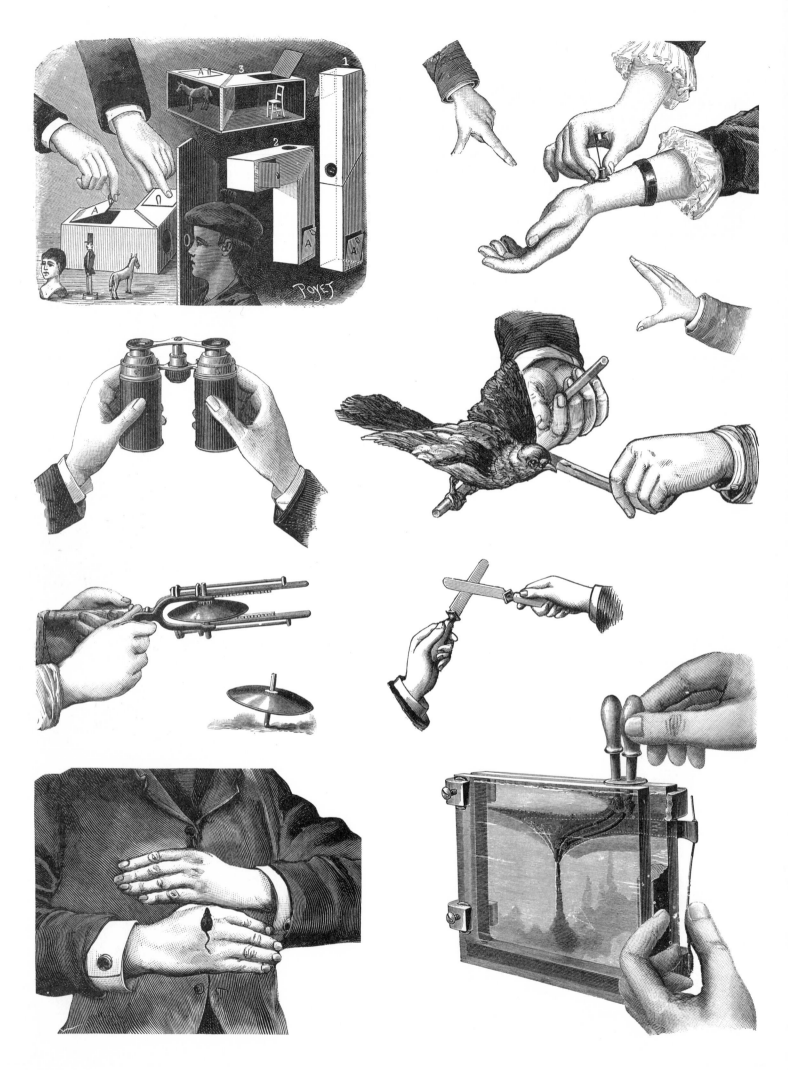

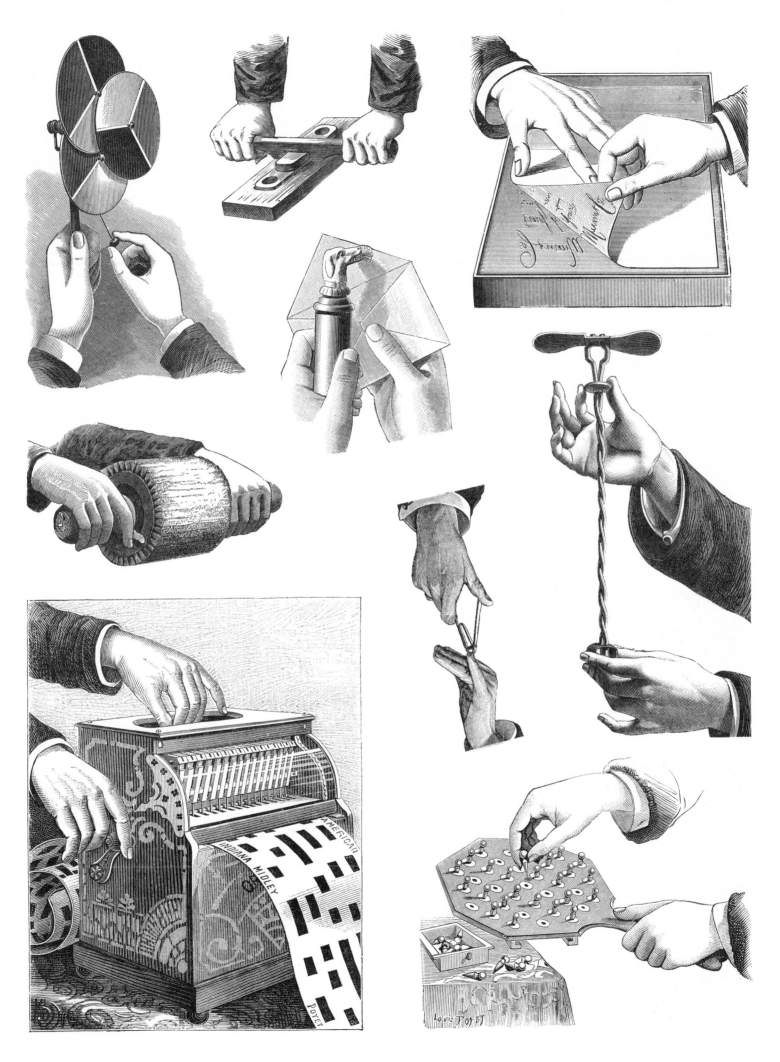

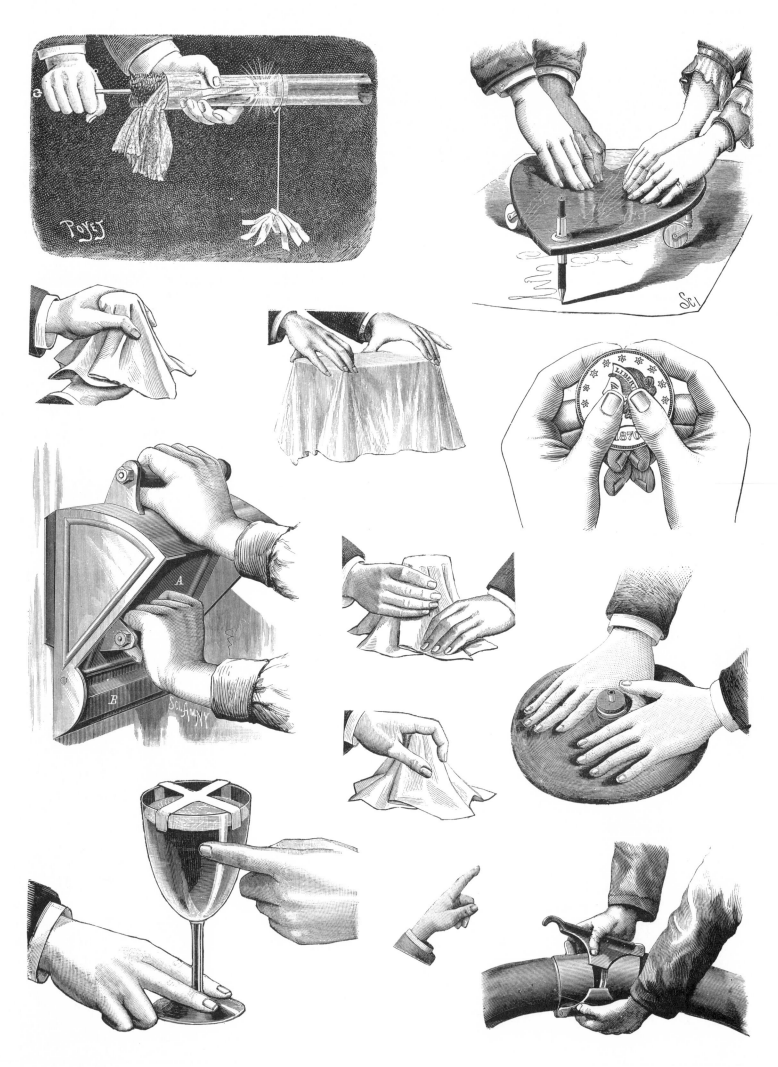

18

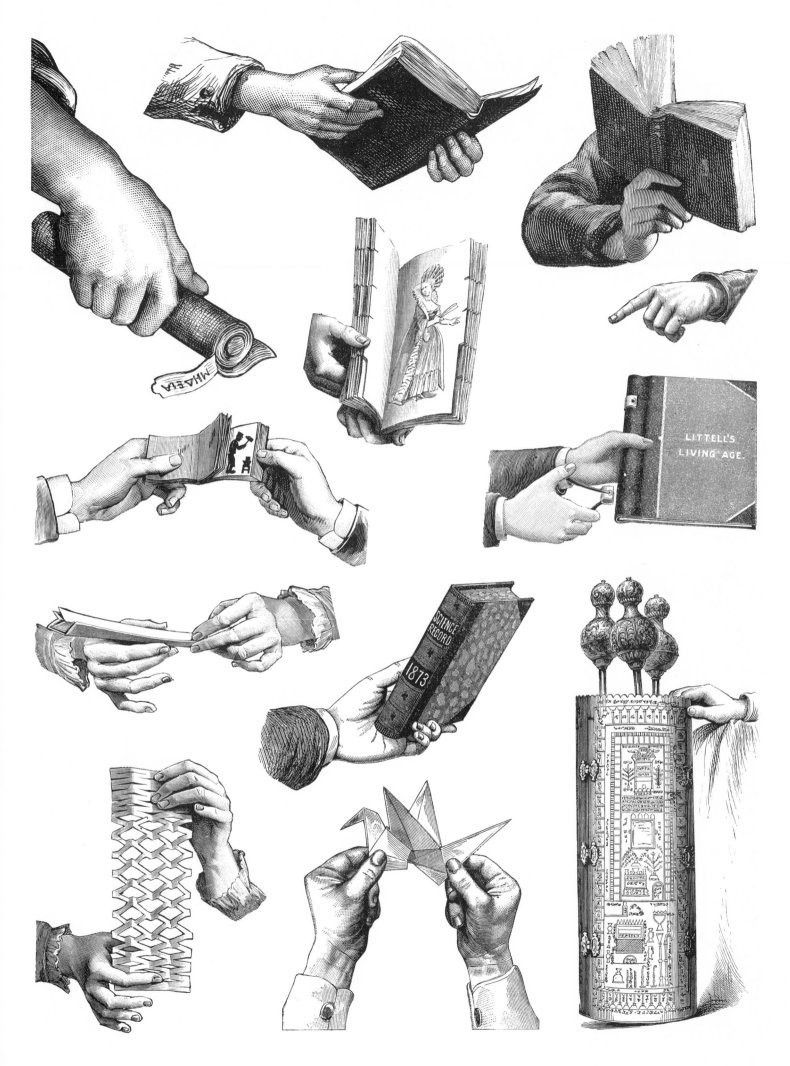

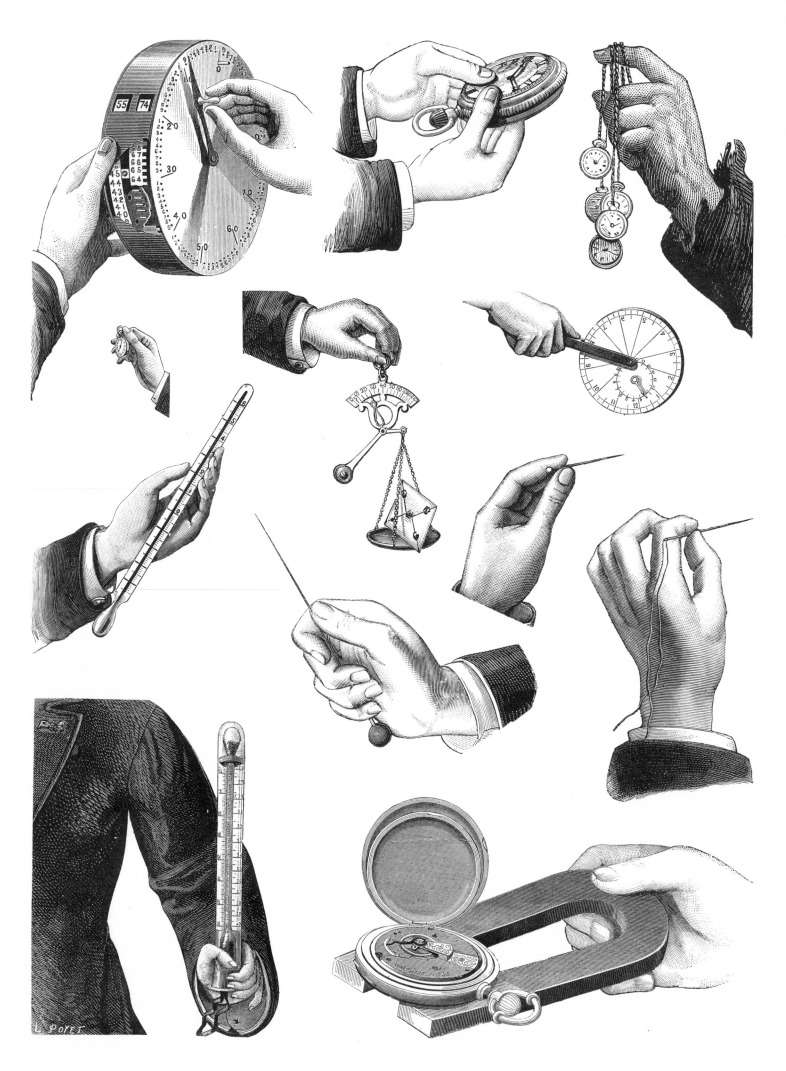

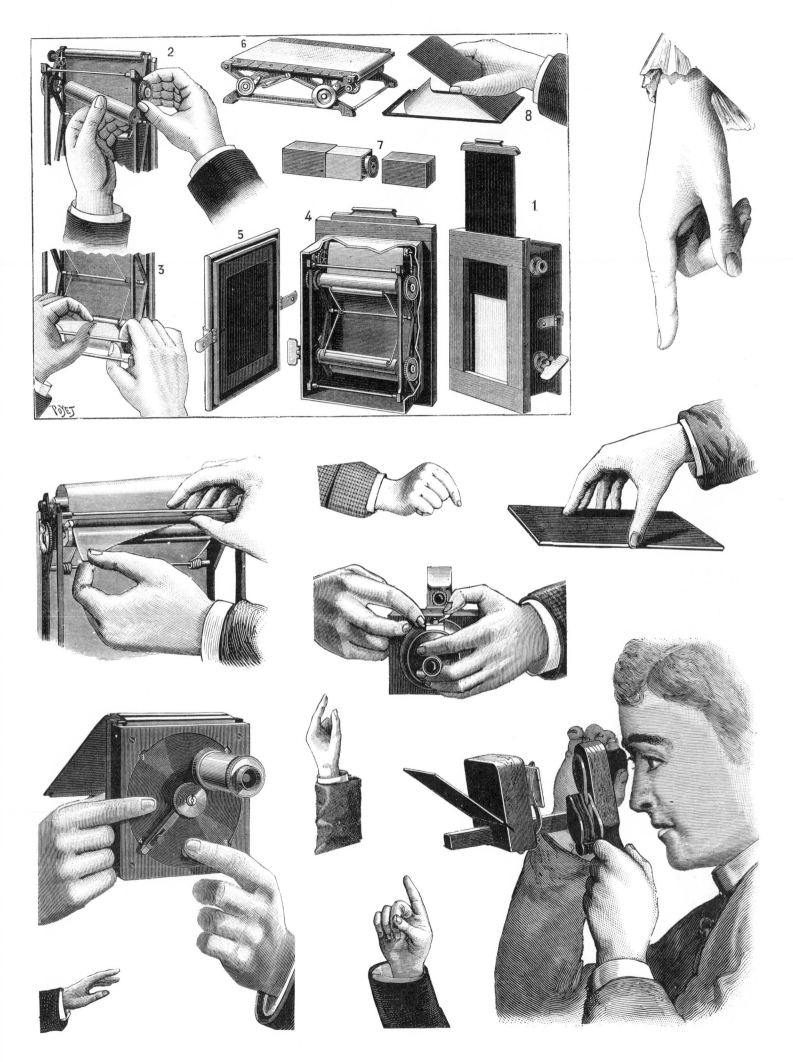

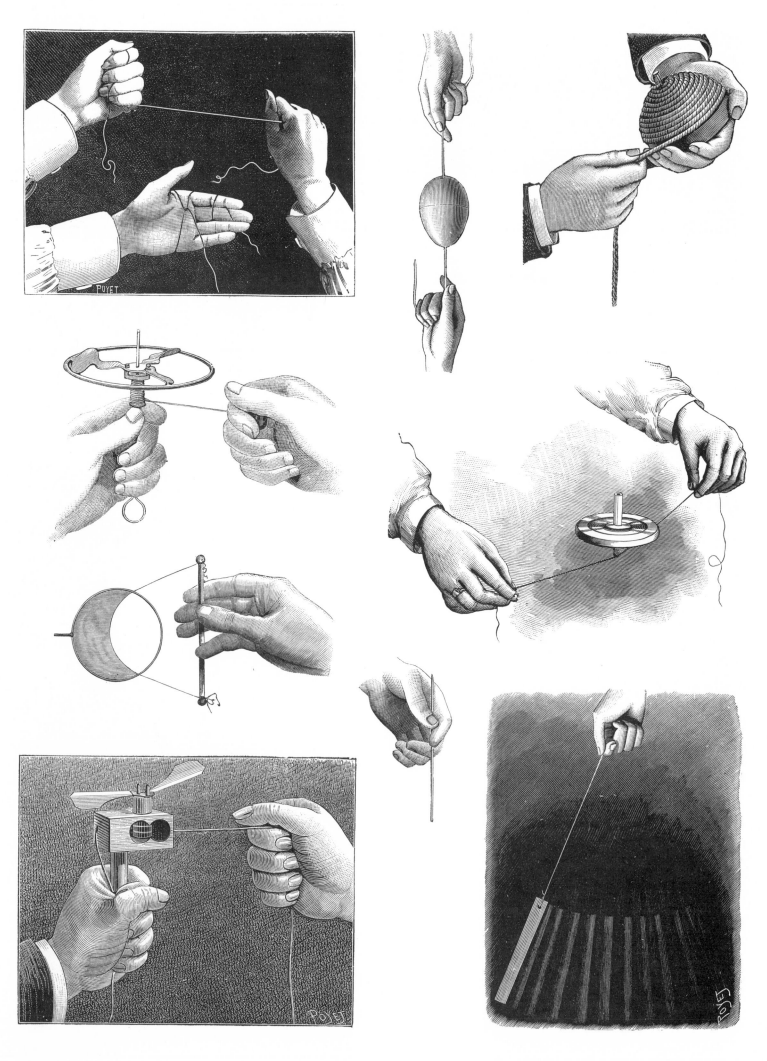

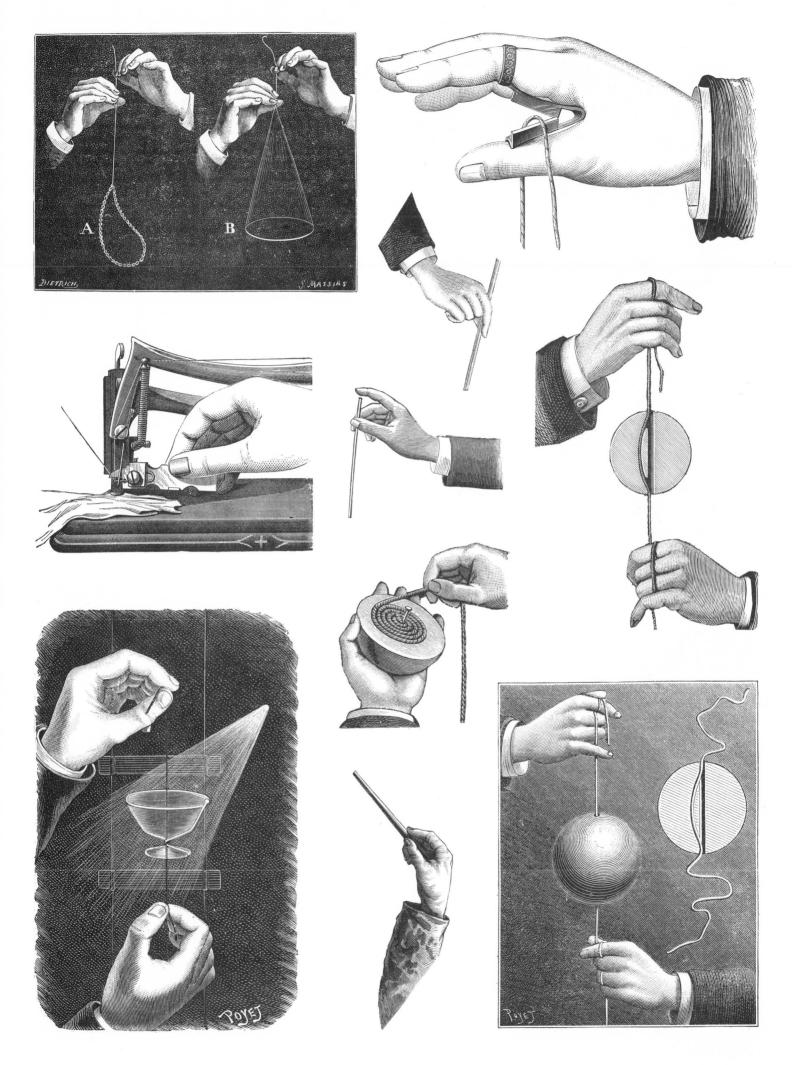

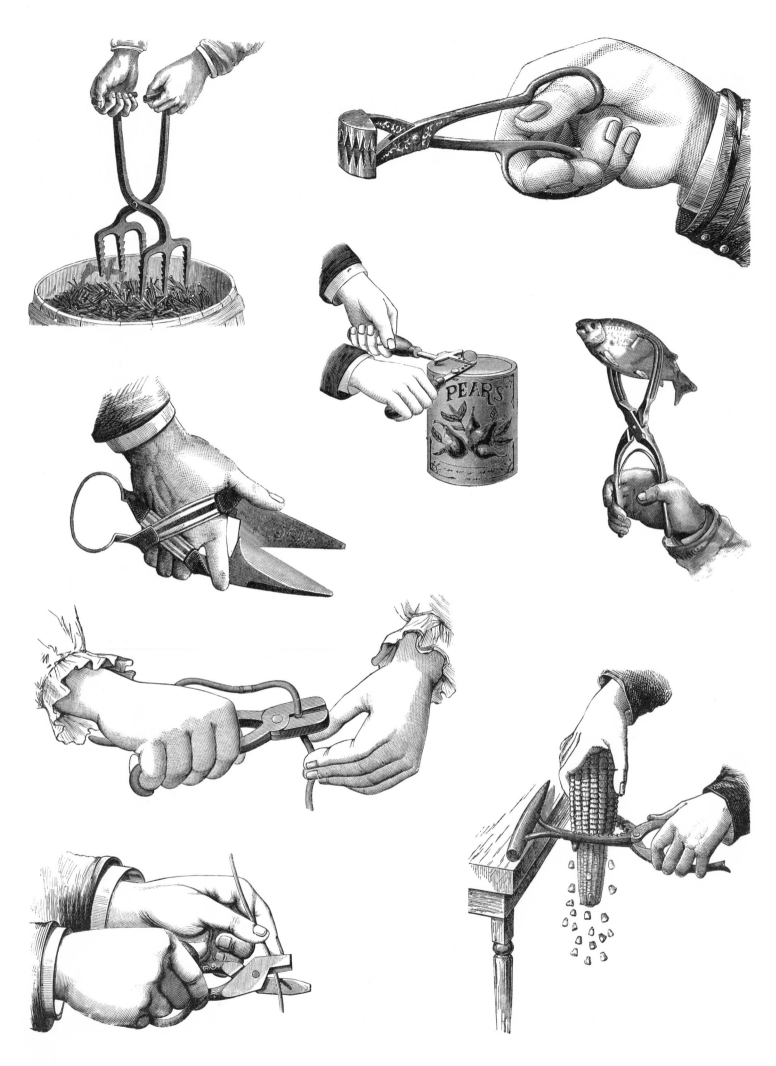

24

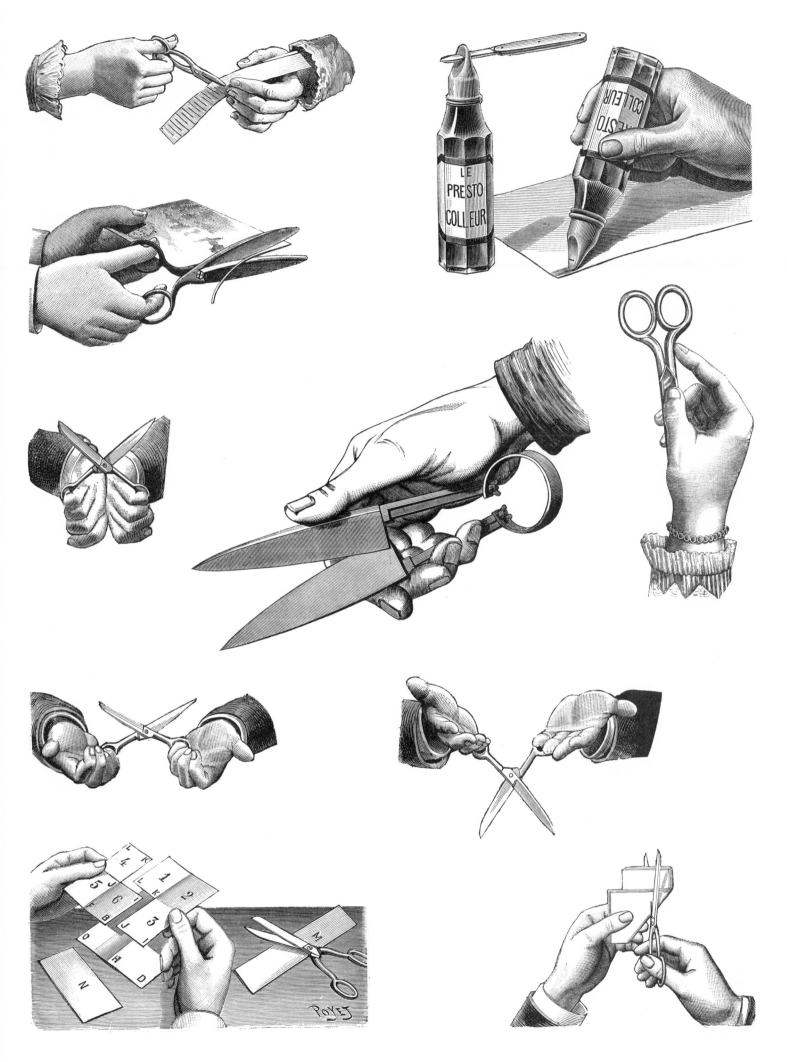

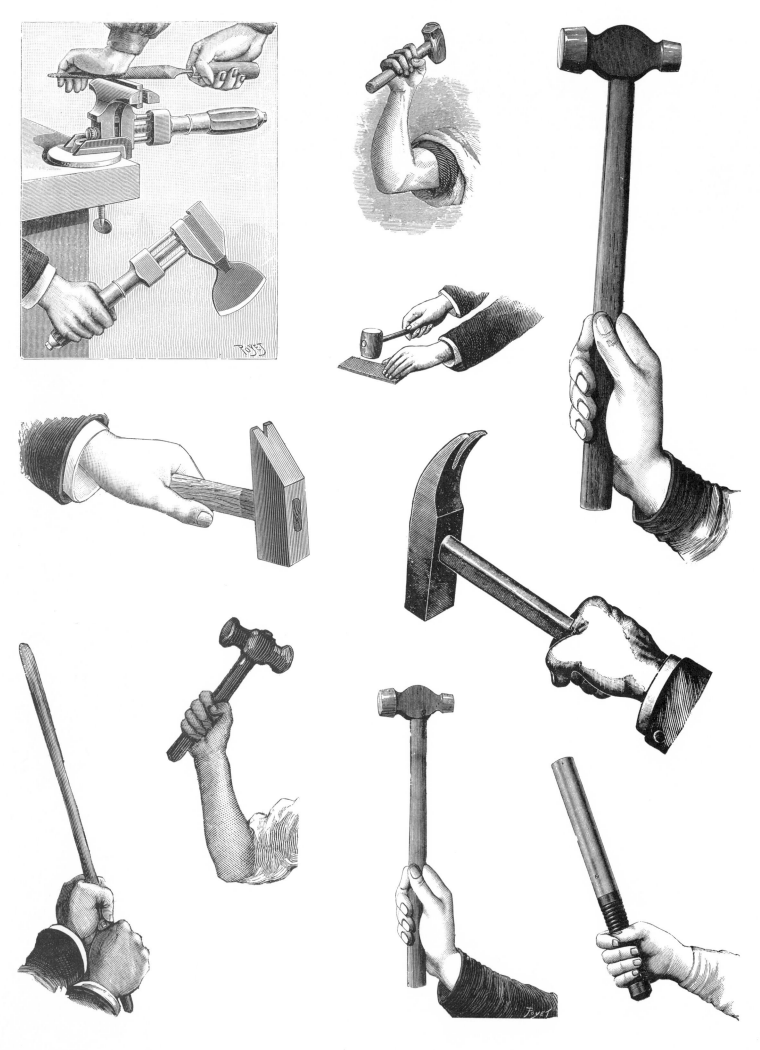

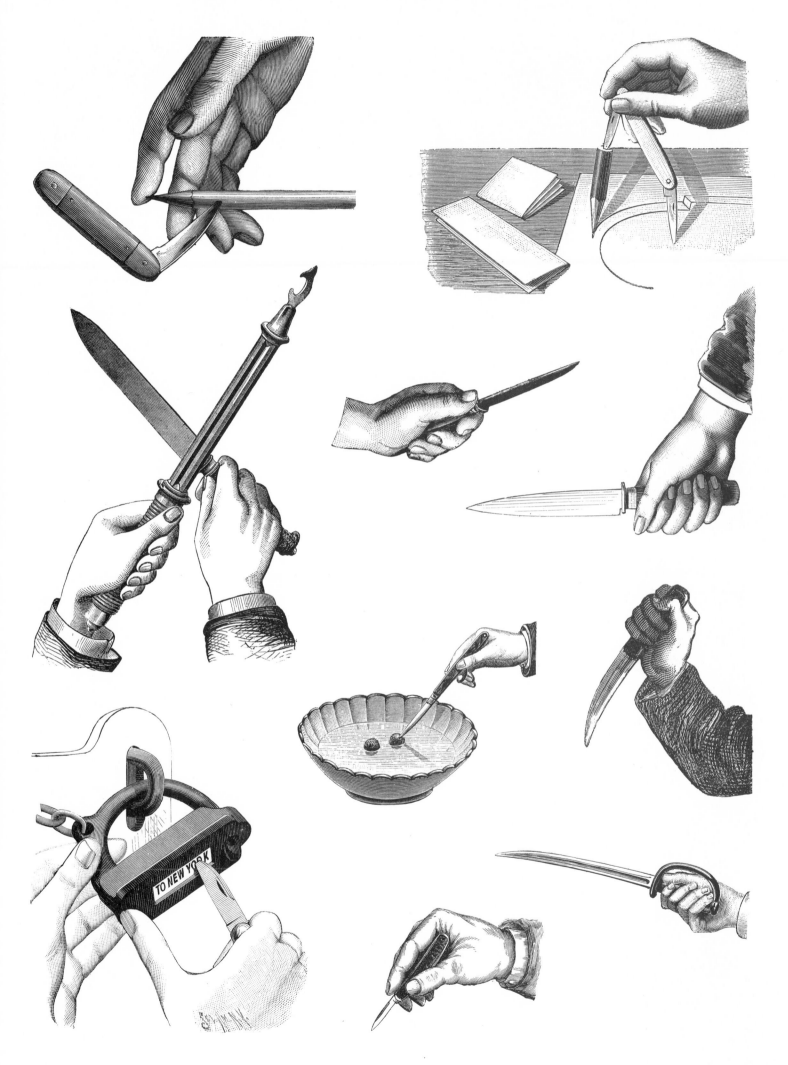

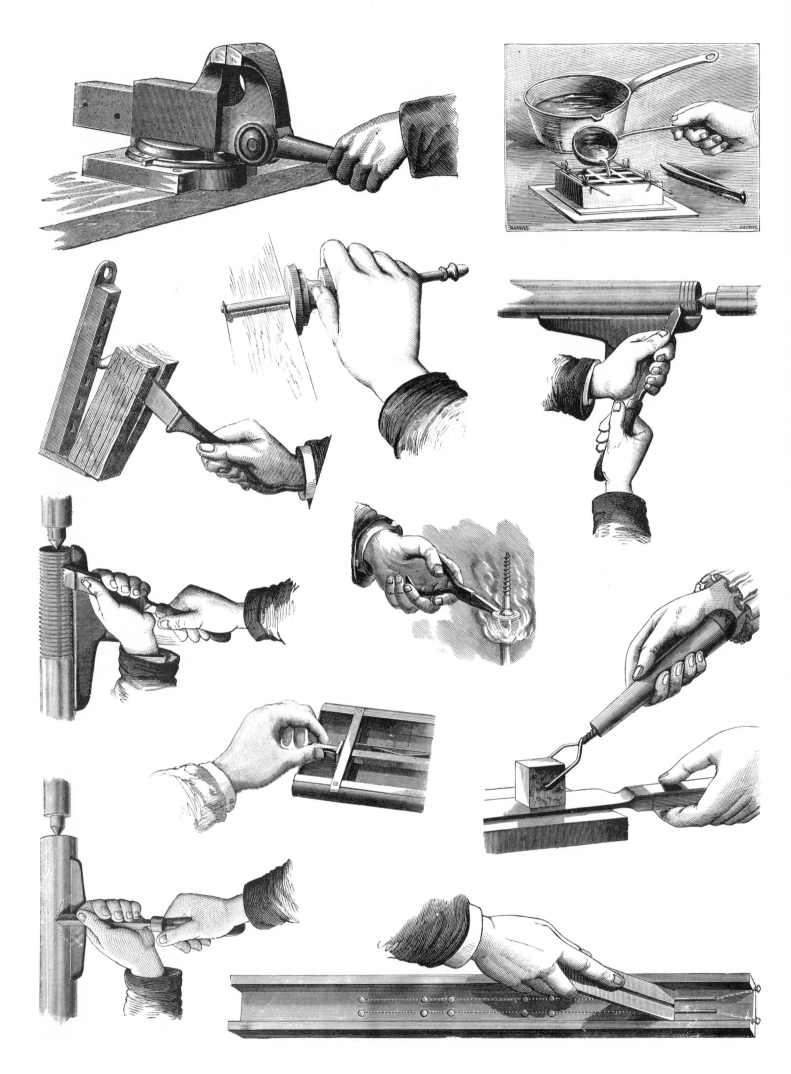

28

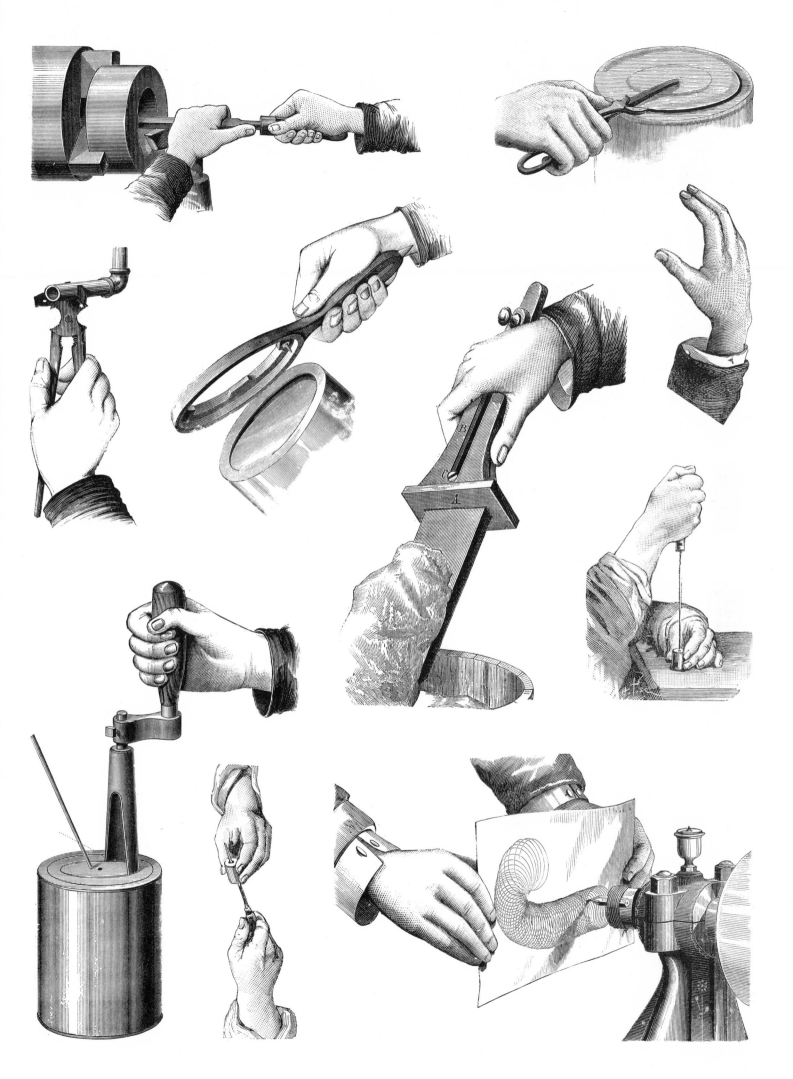

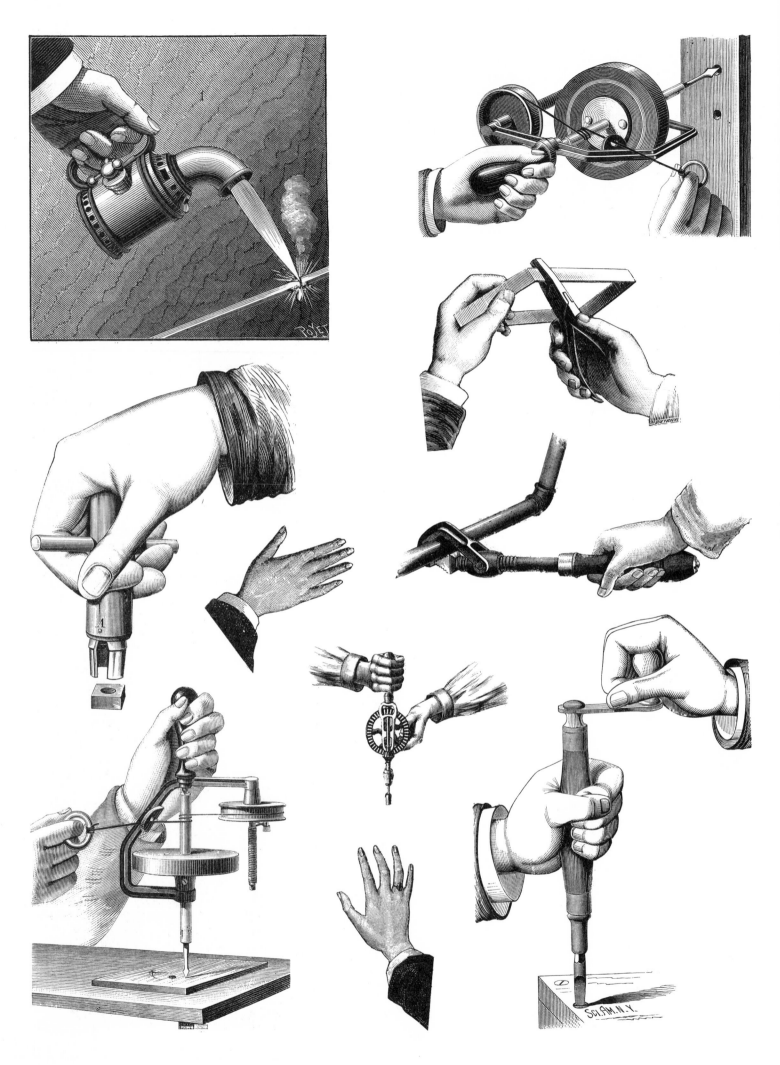

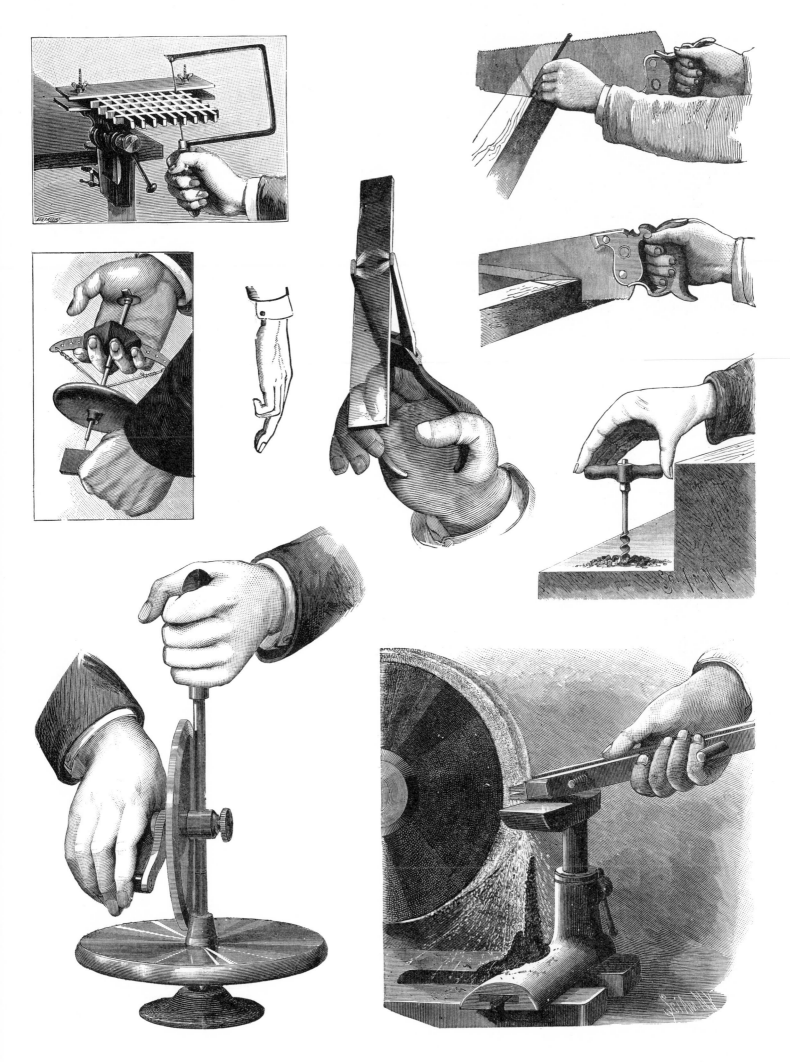

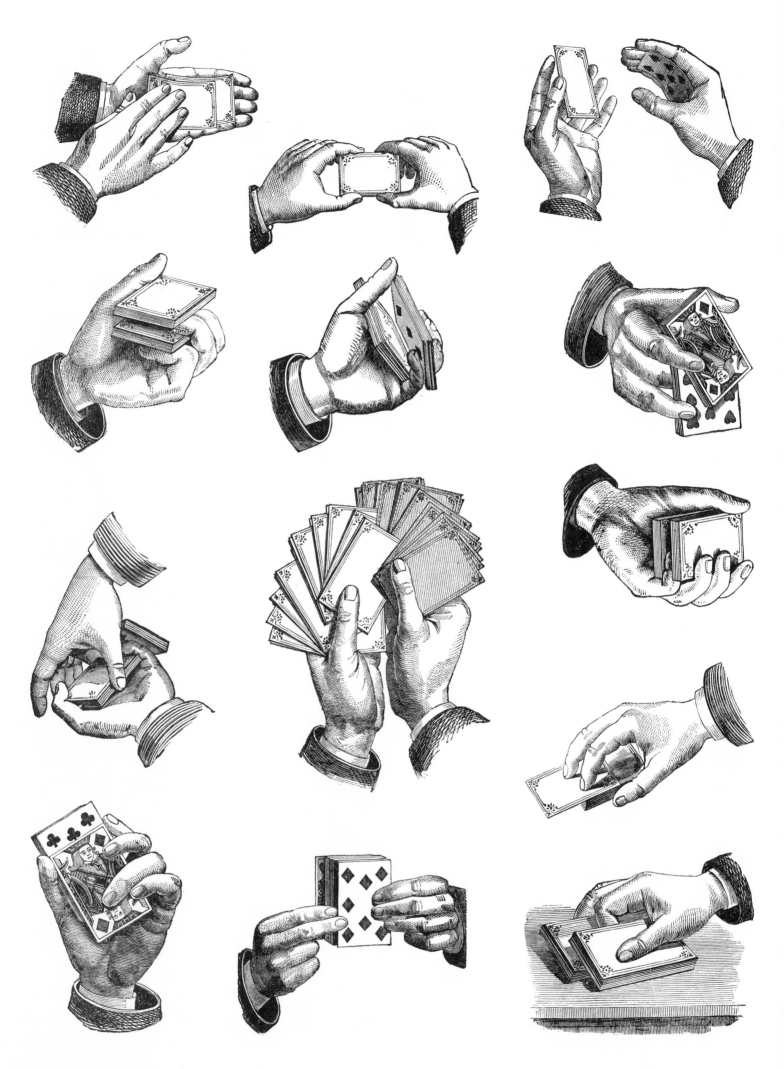

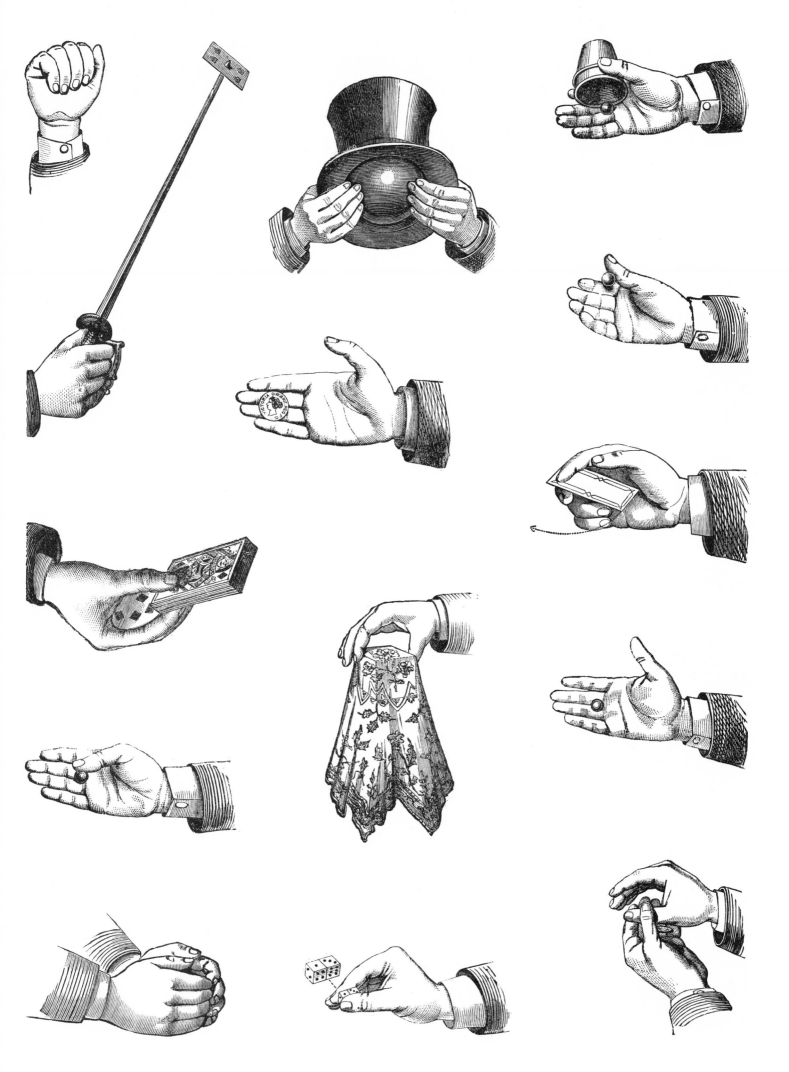

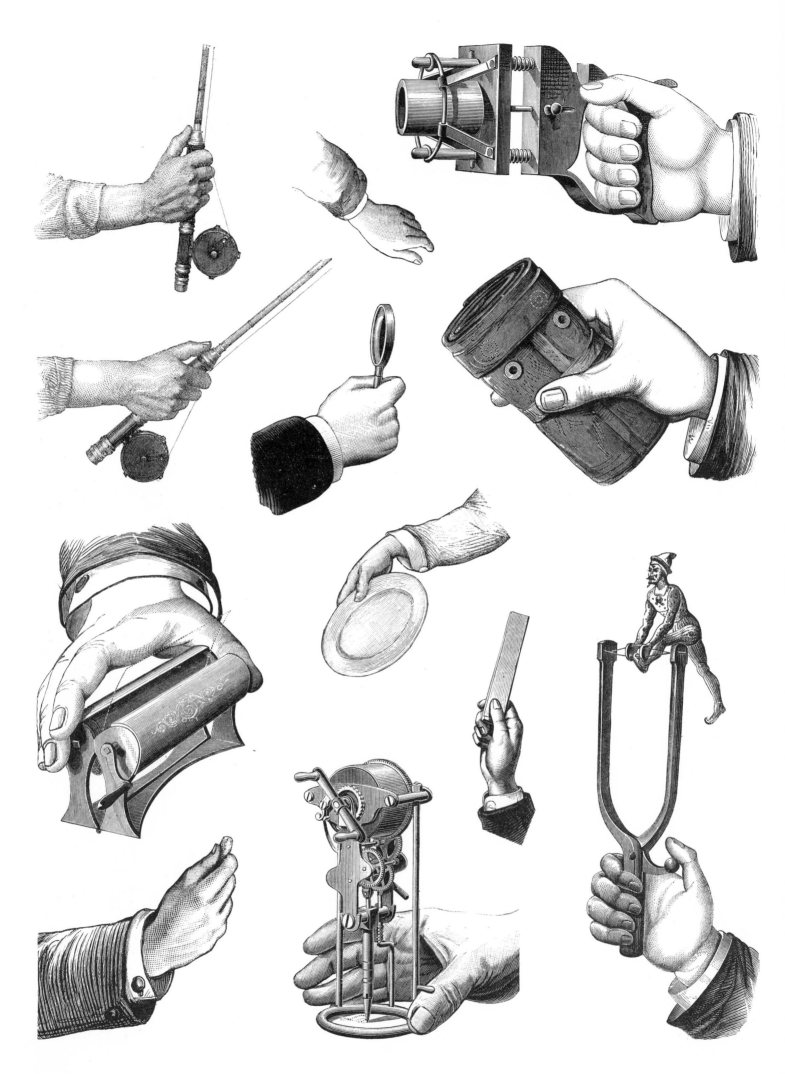

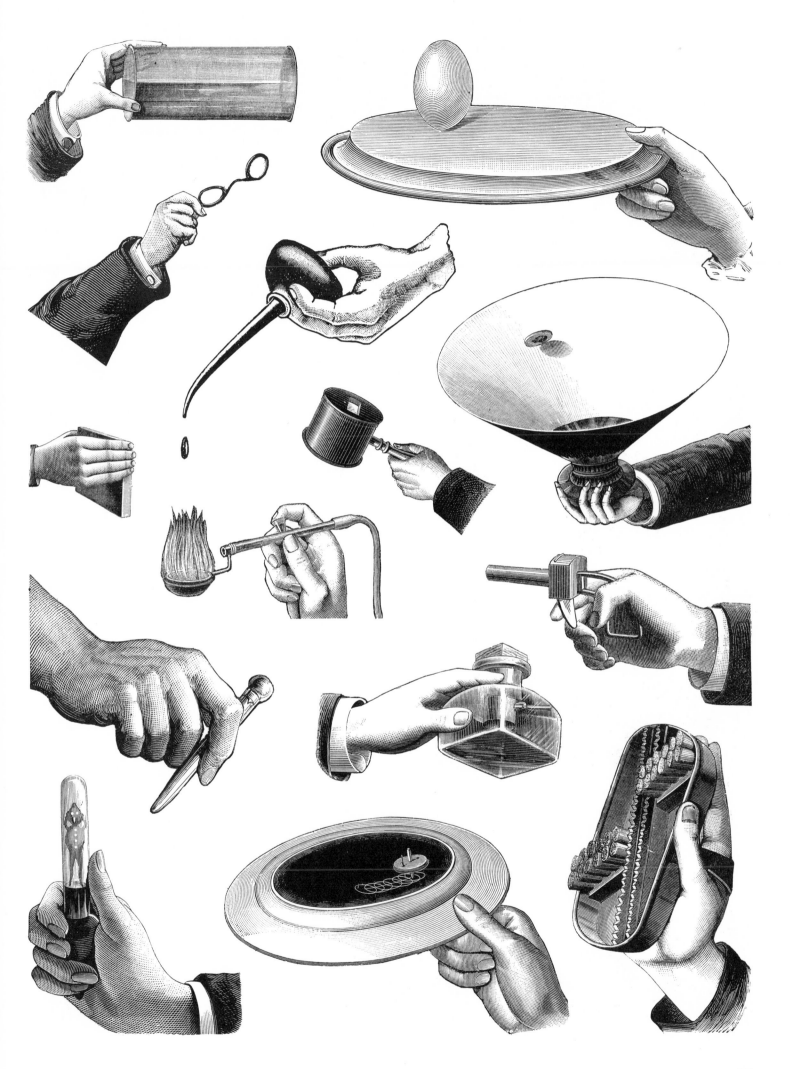

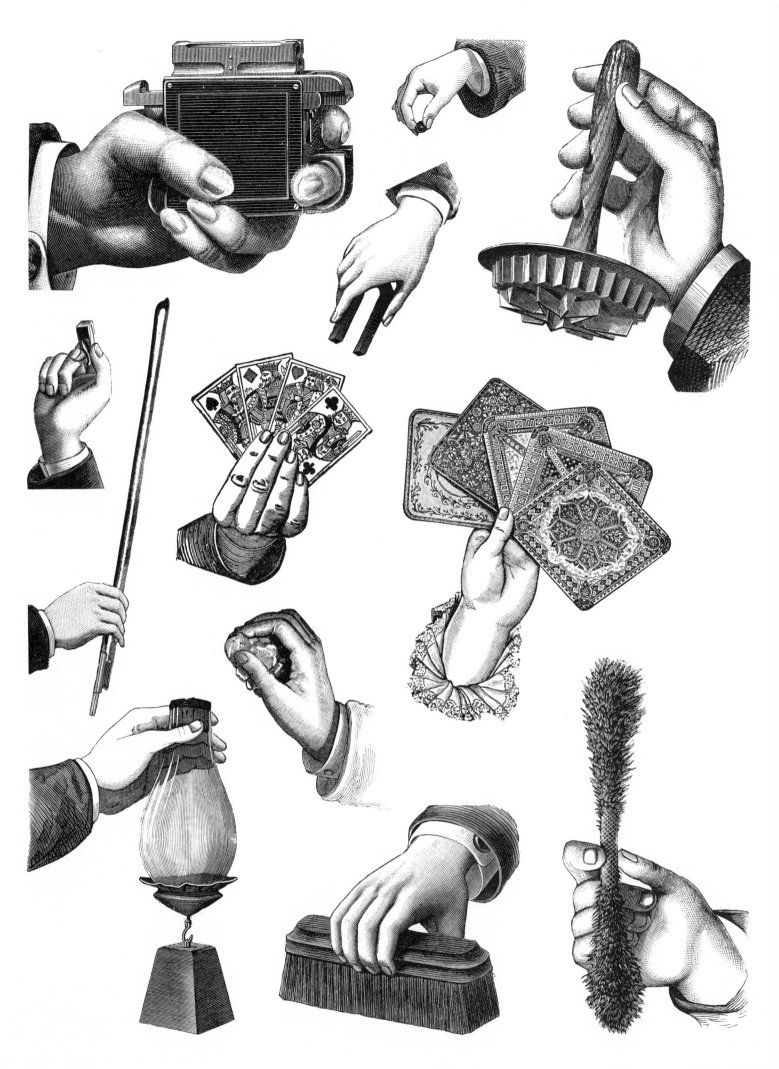

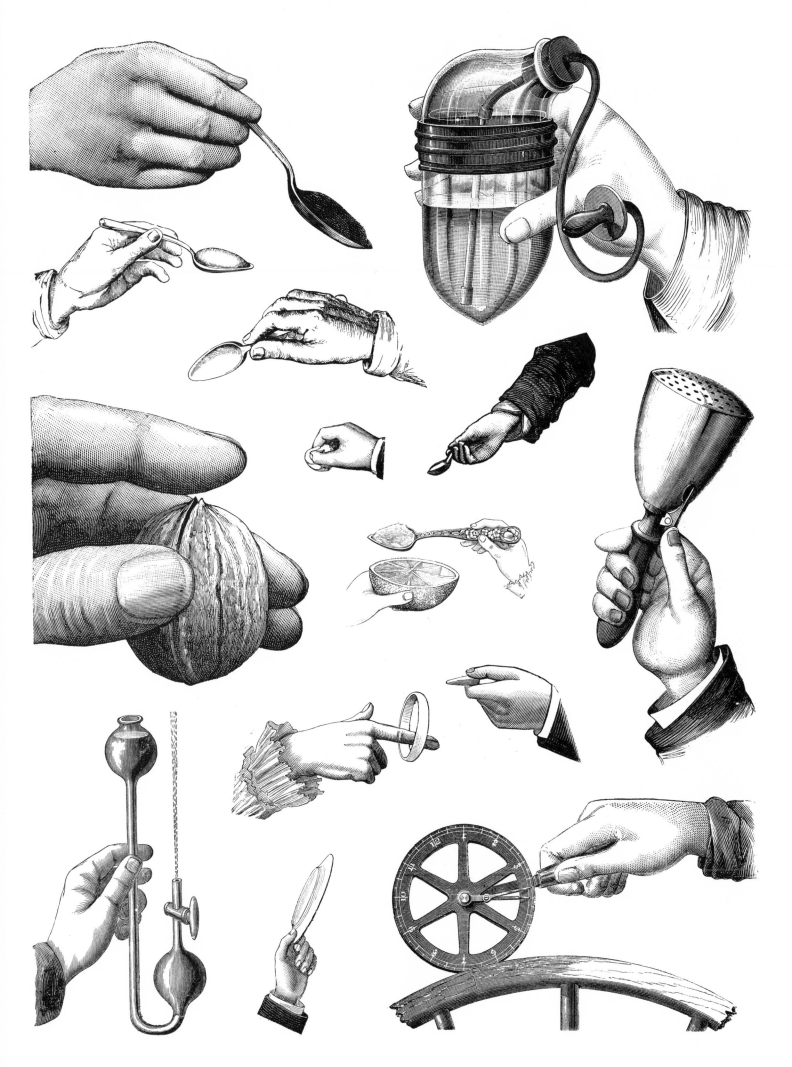

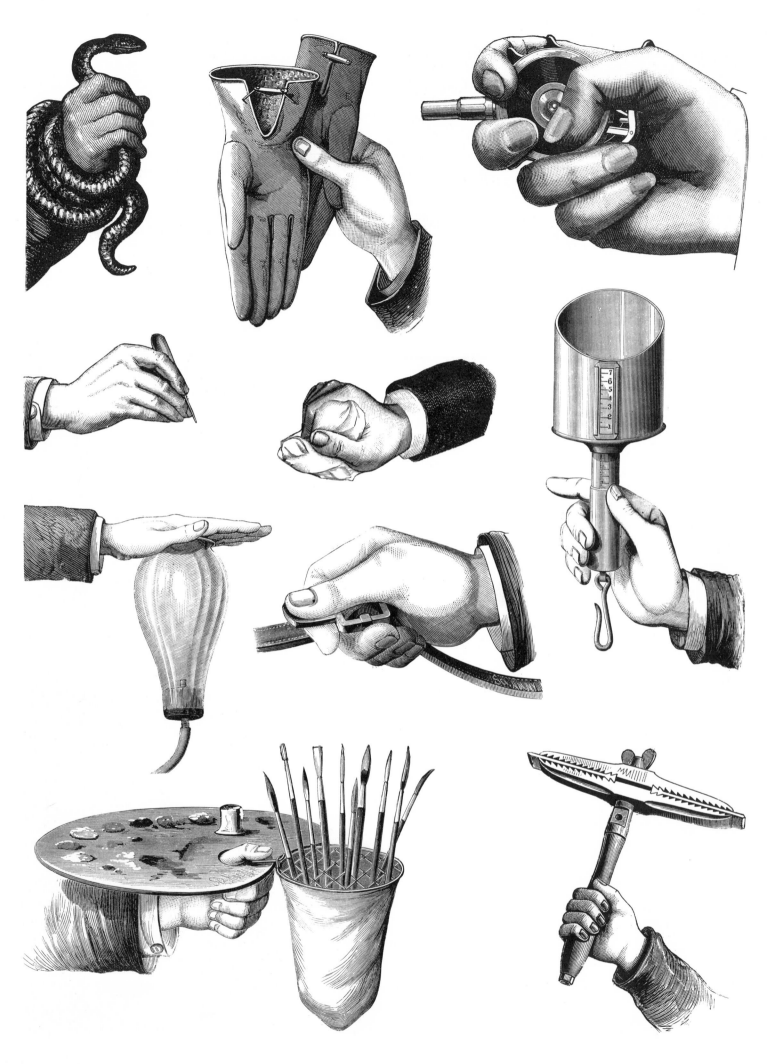

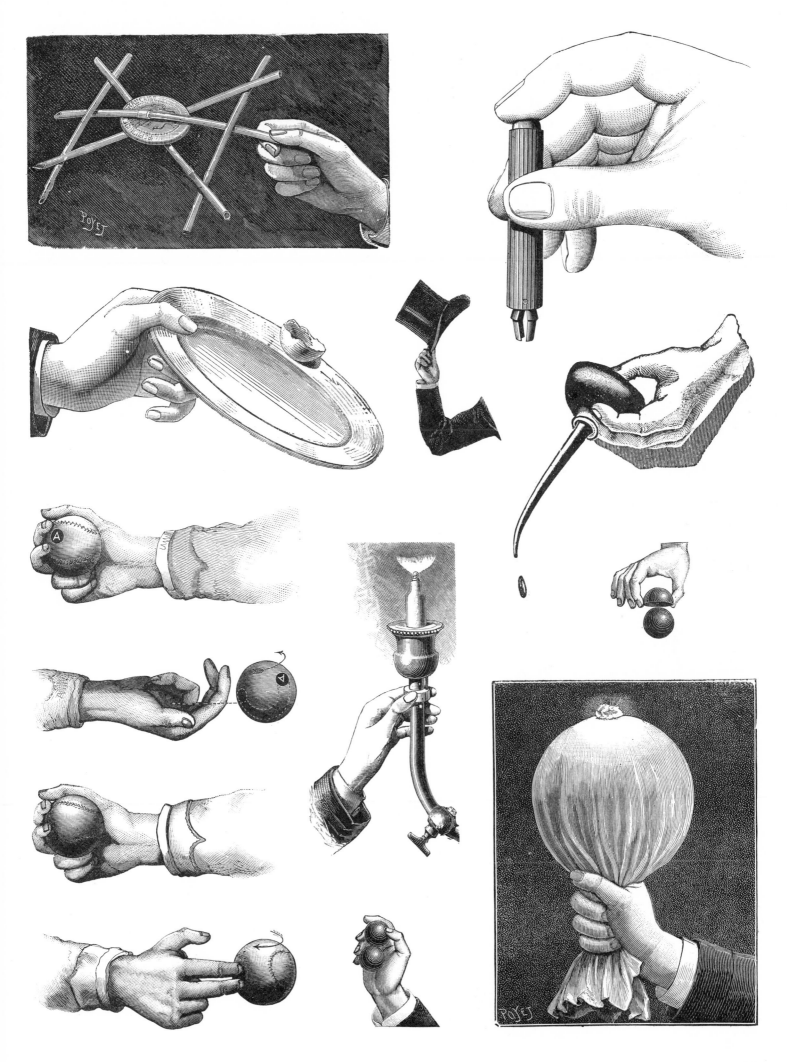

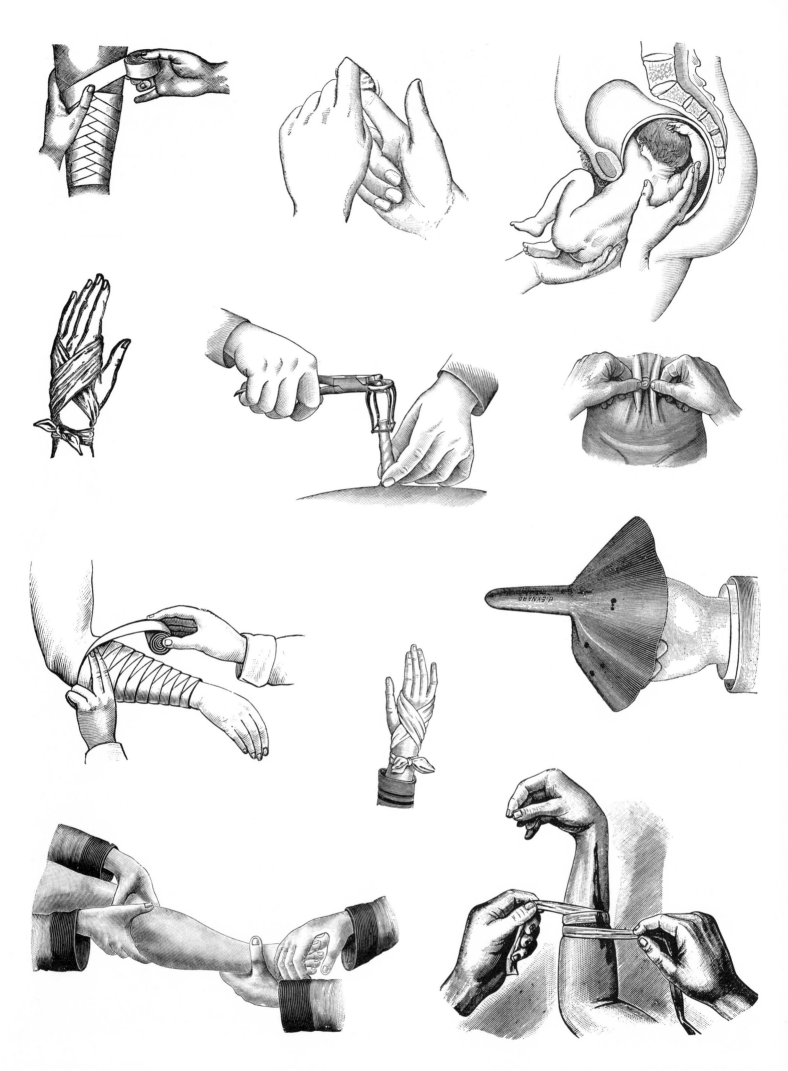

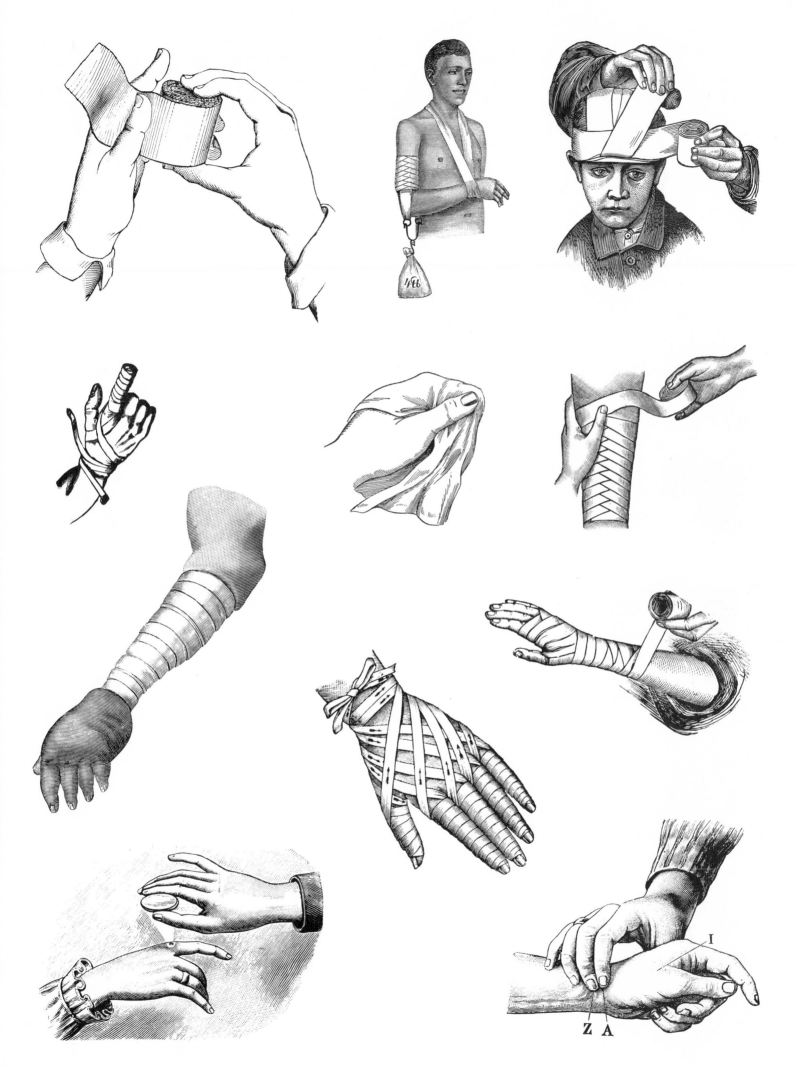

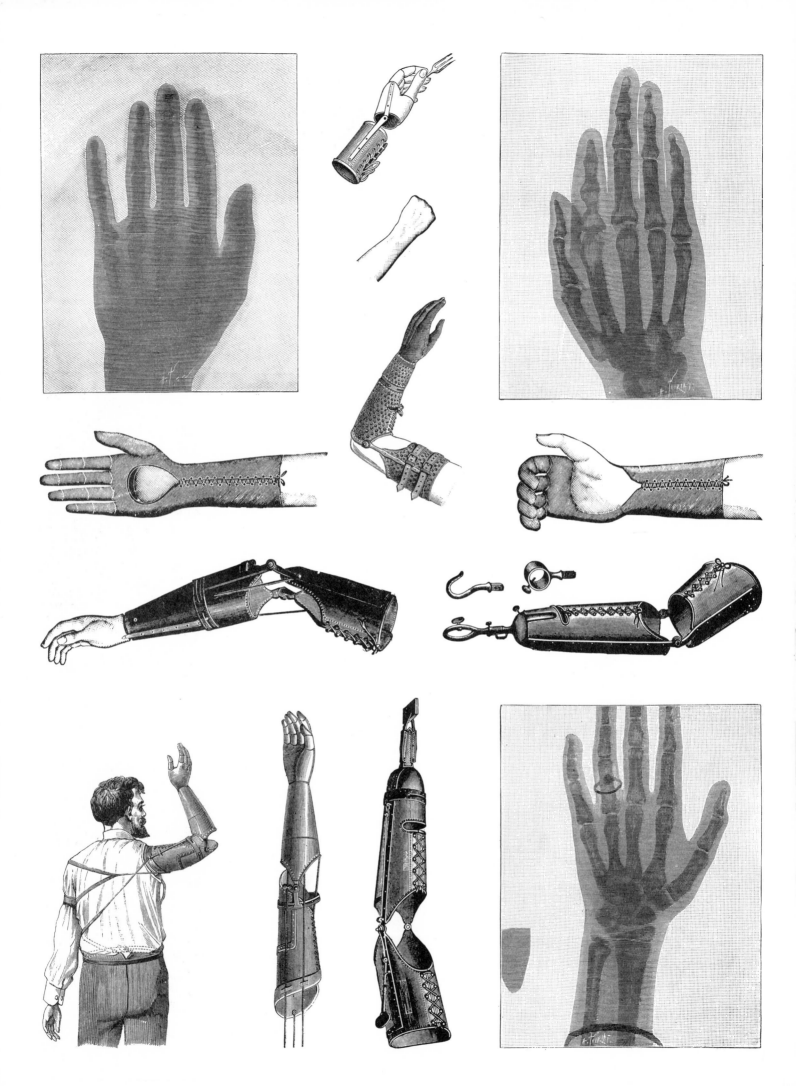

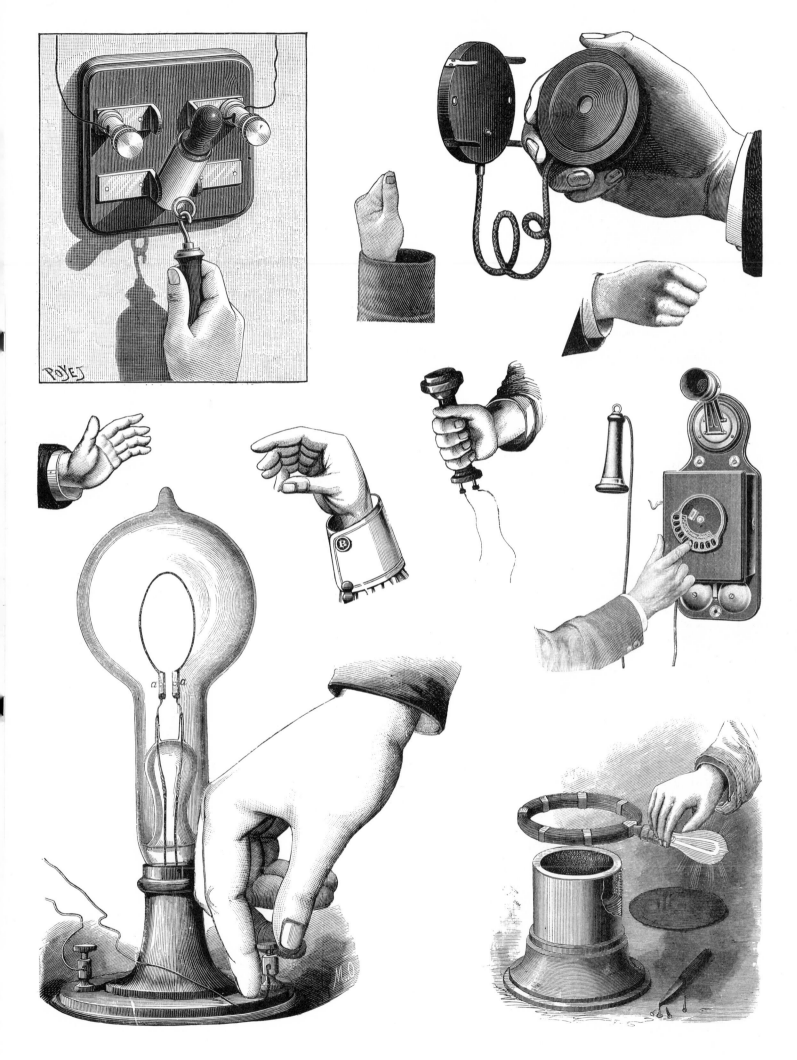

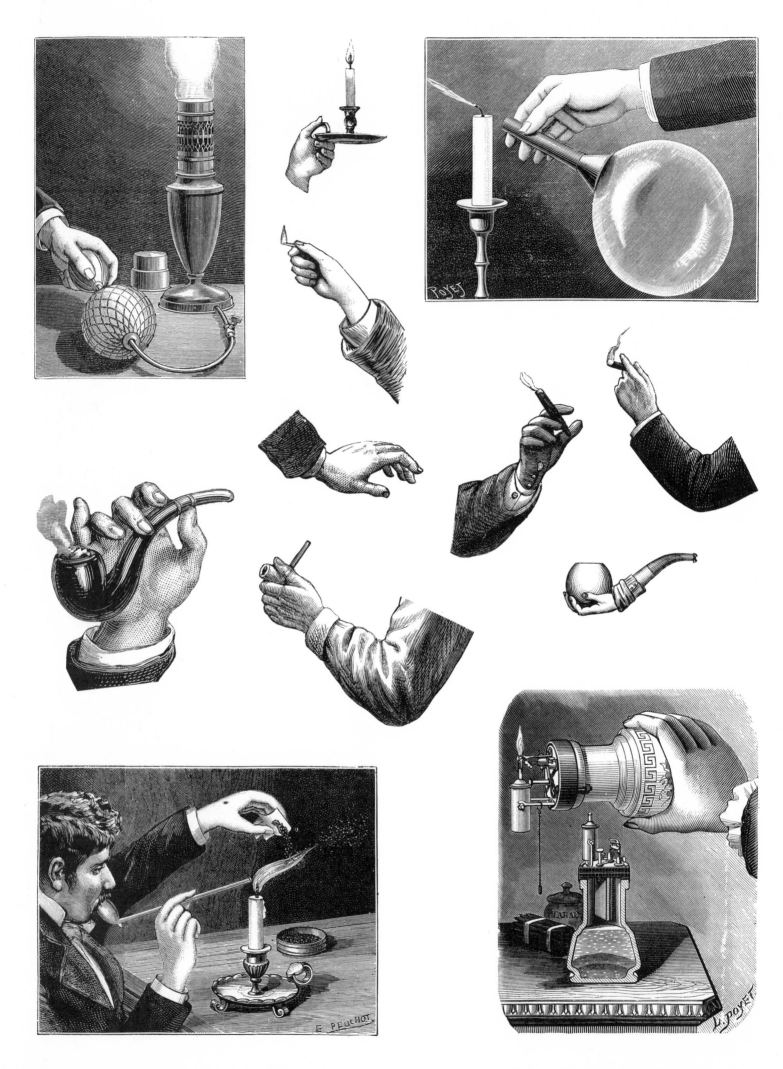

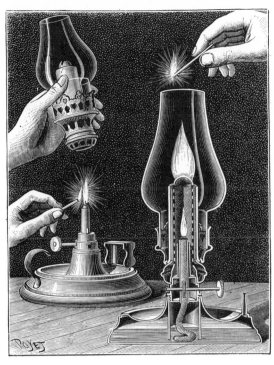

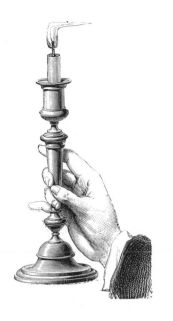

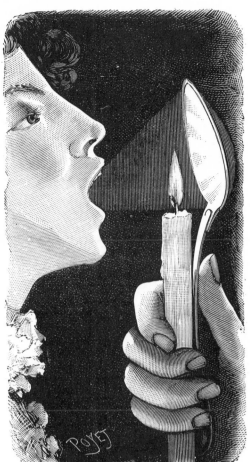

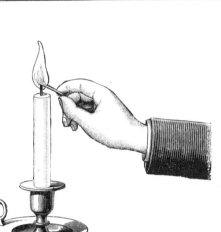

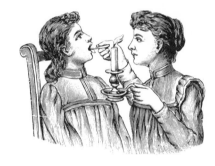

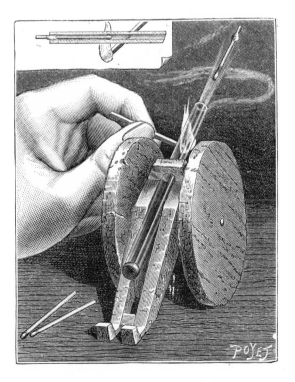

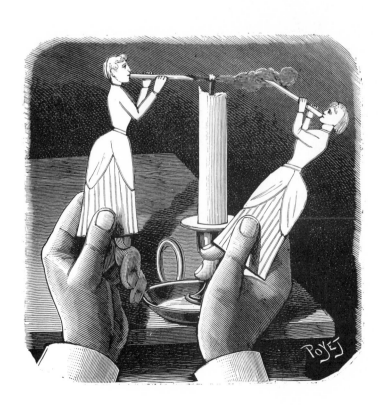

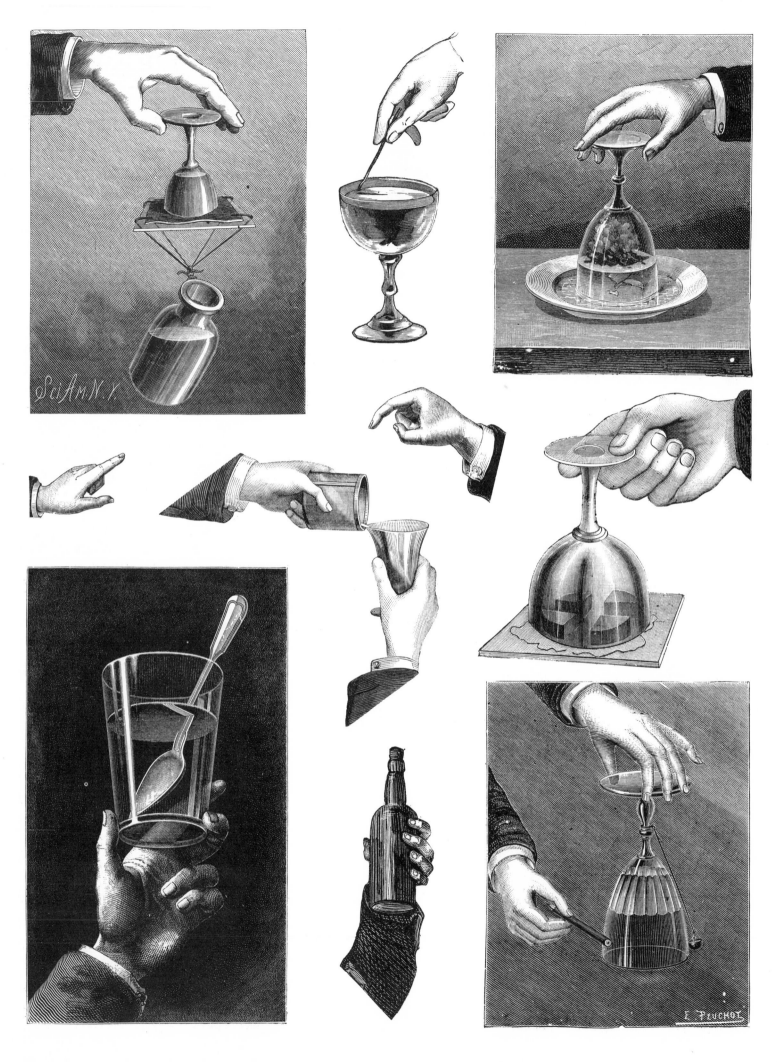

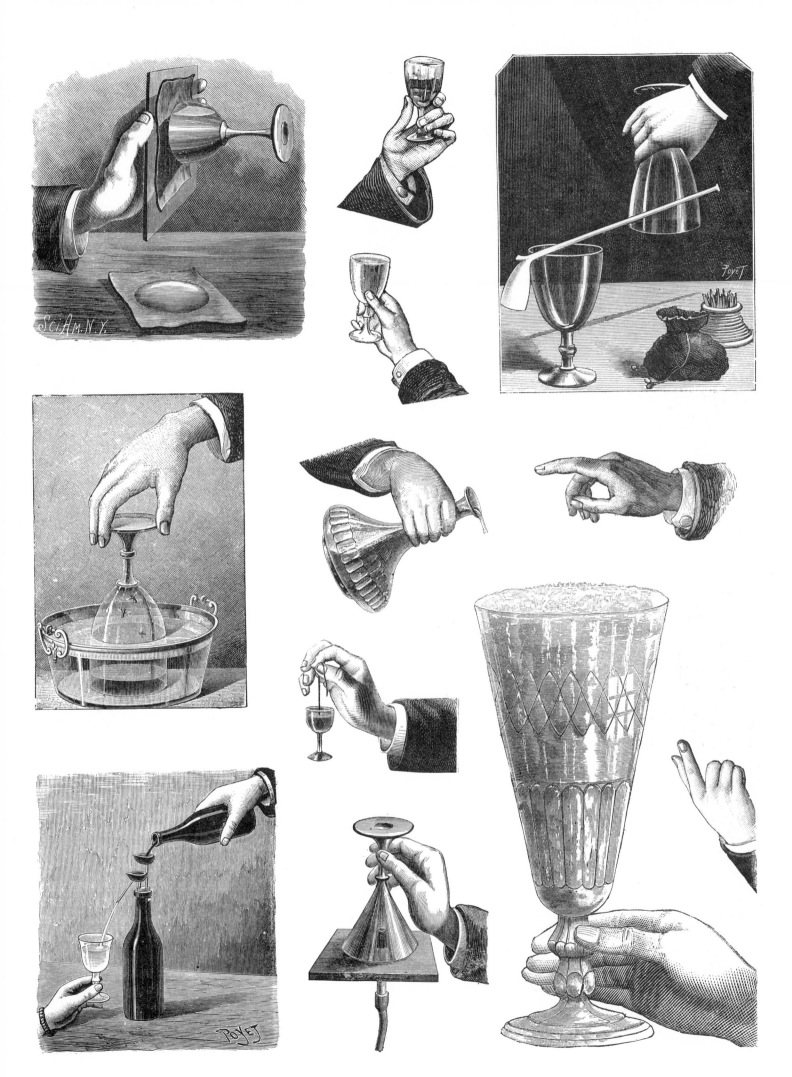

47

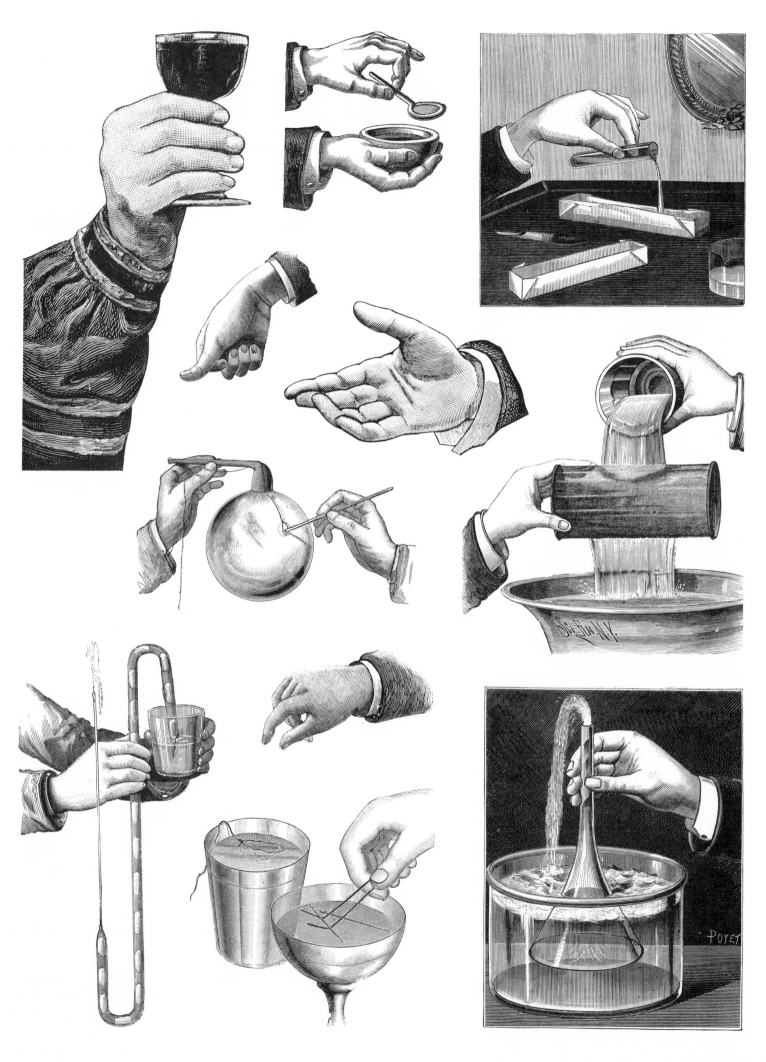

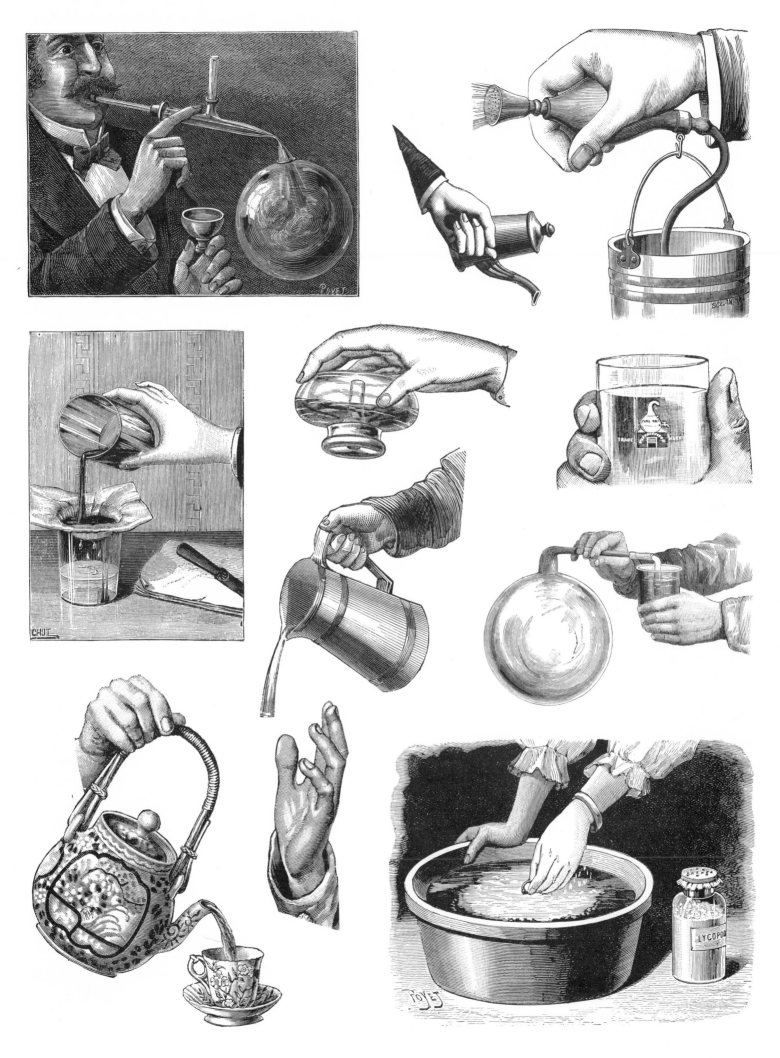

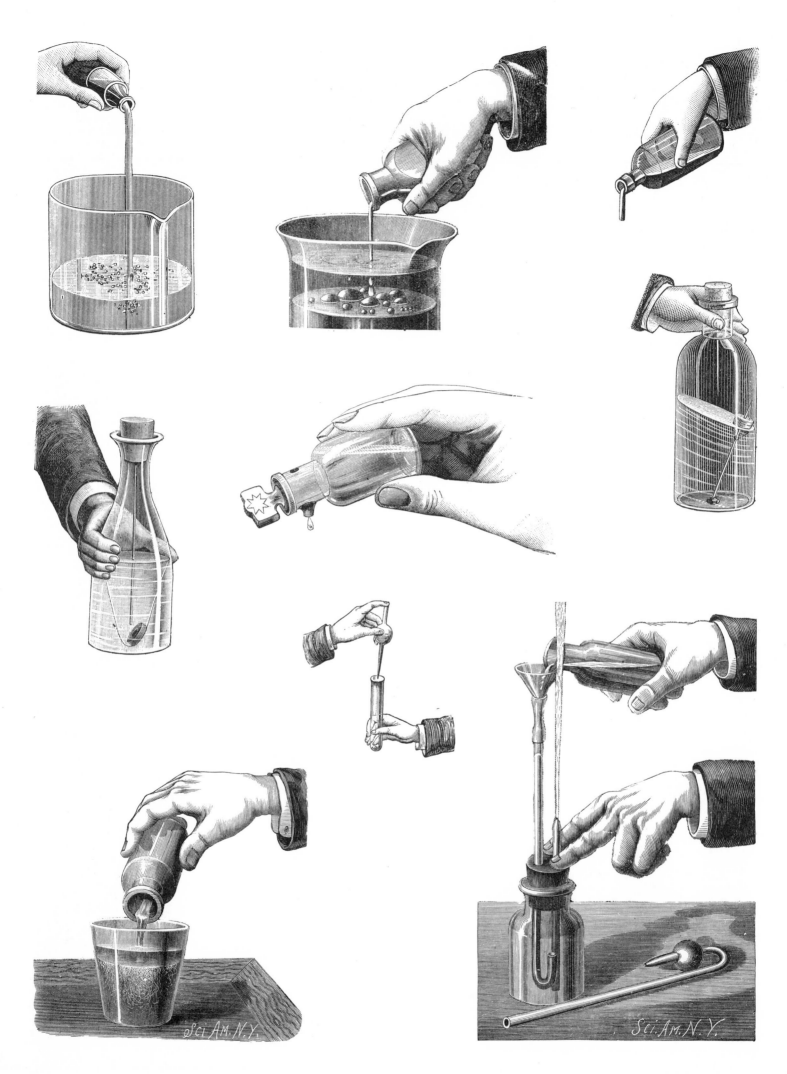

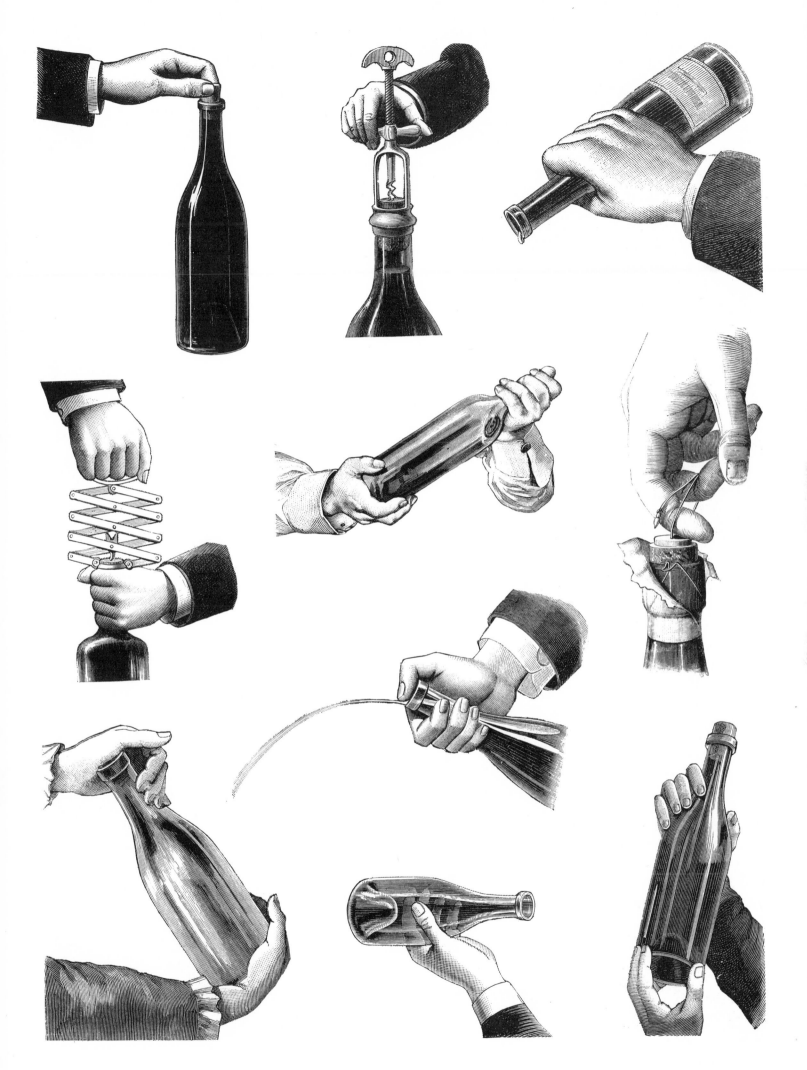

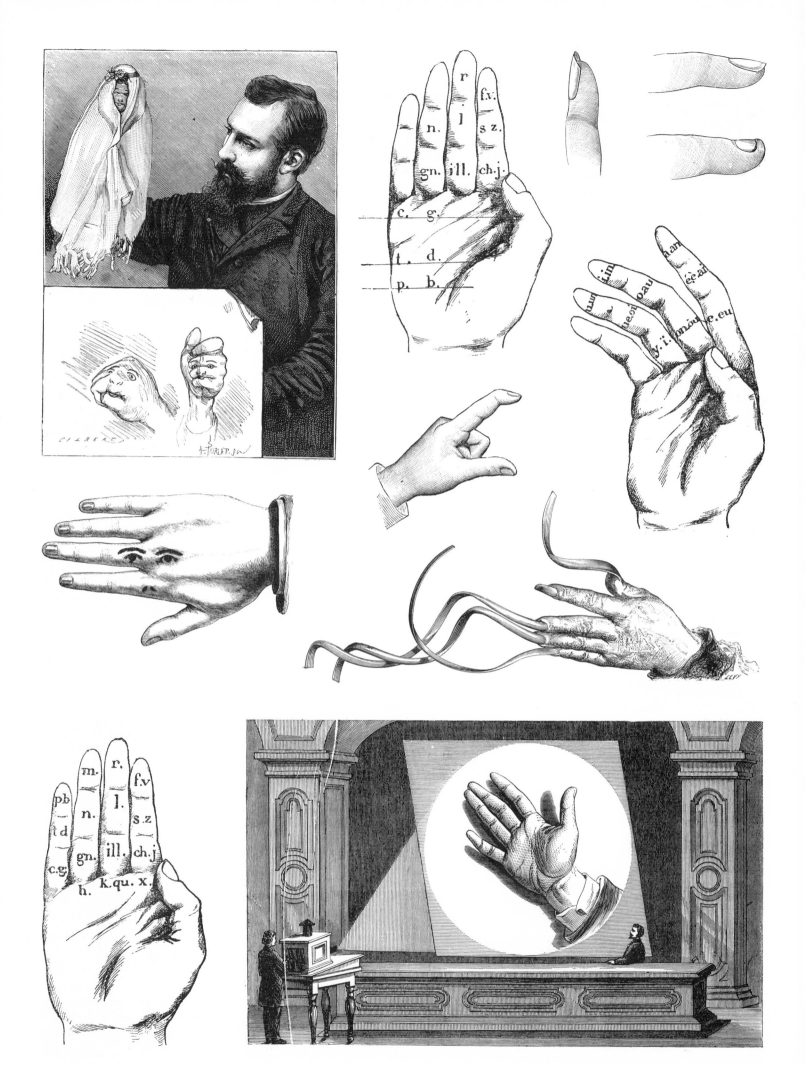

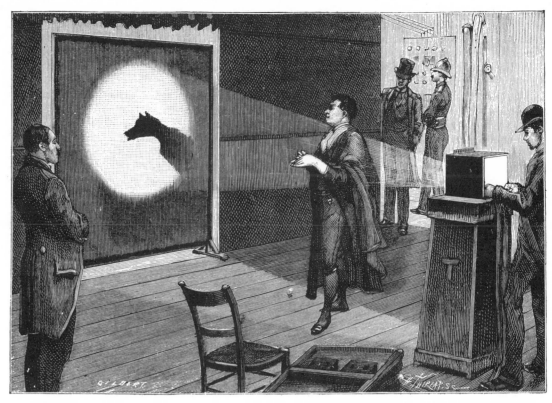

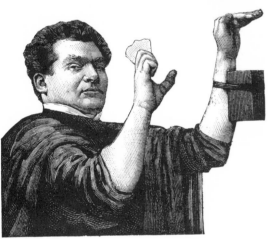

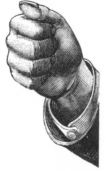

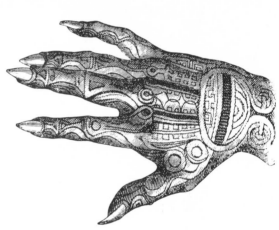

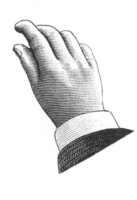

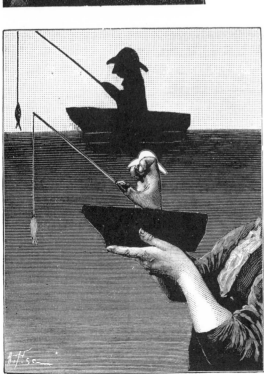

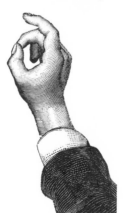

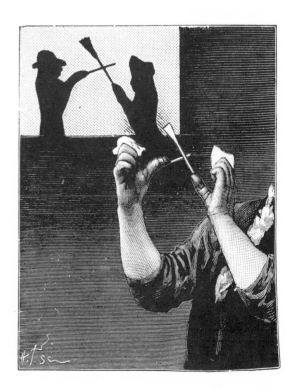

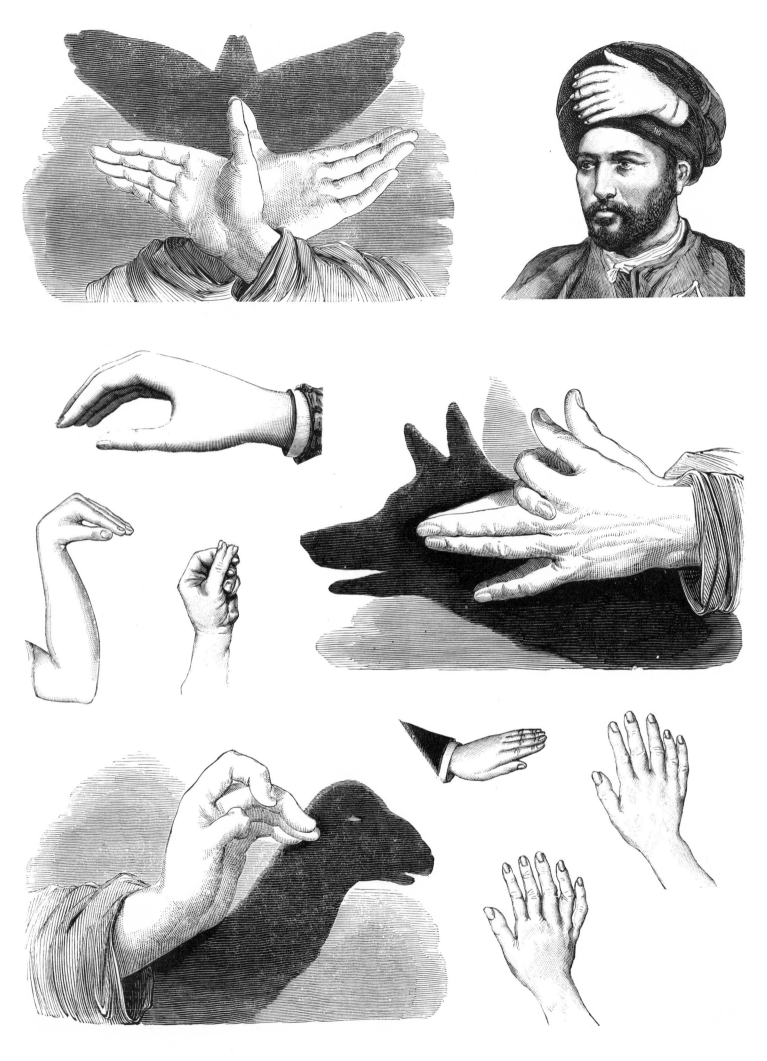

54

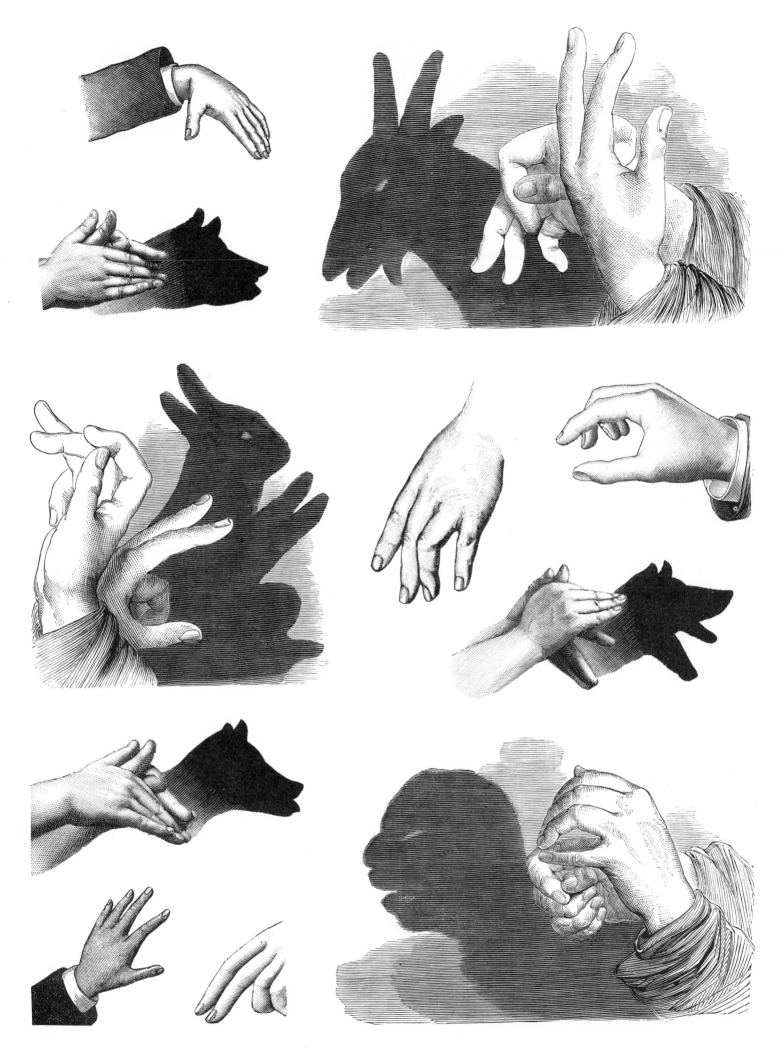

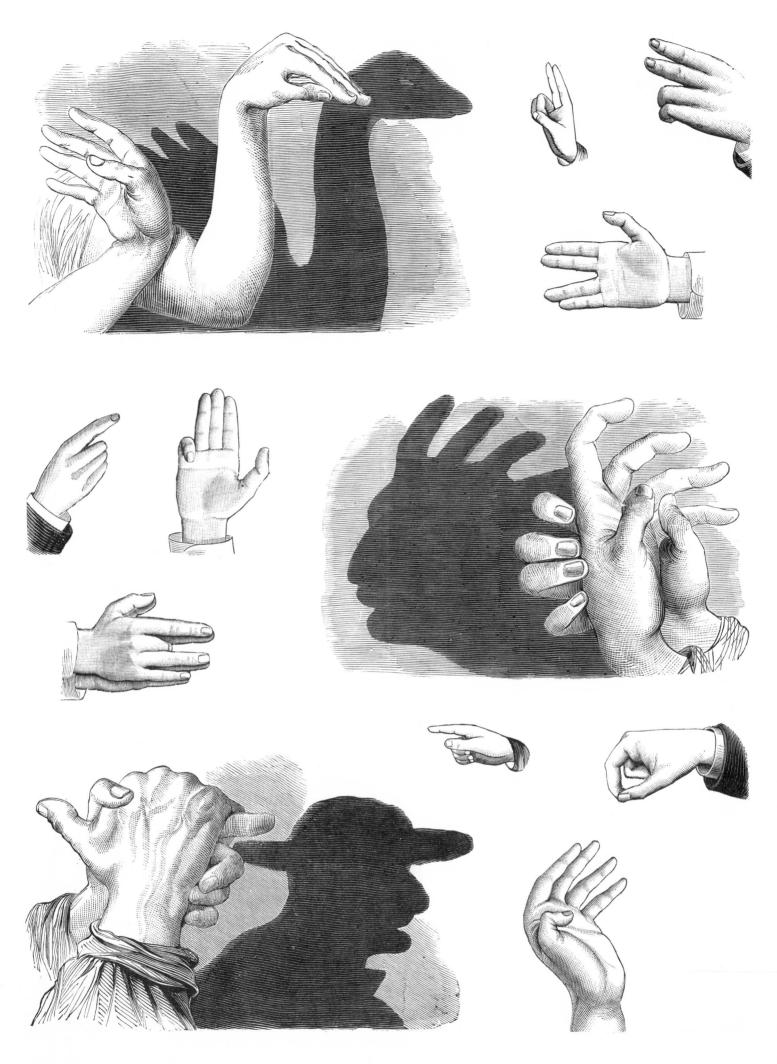

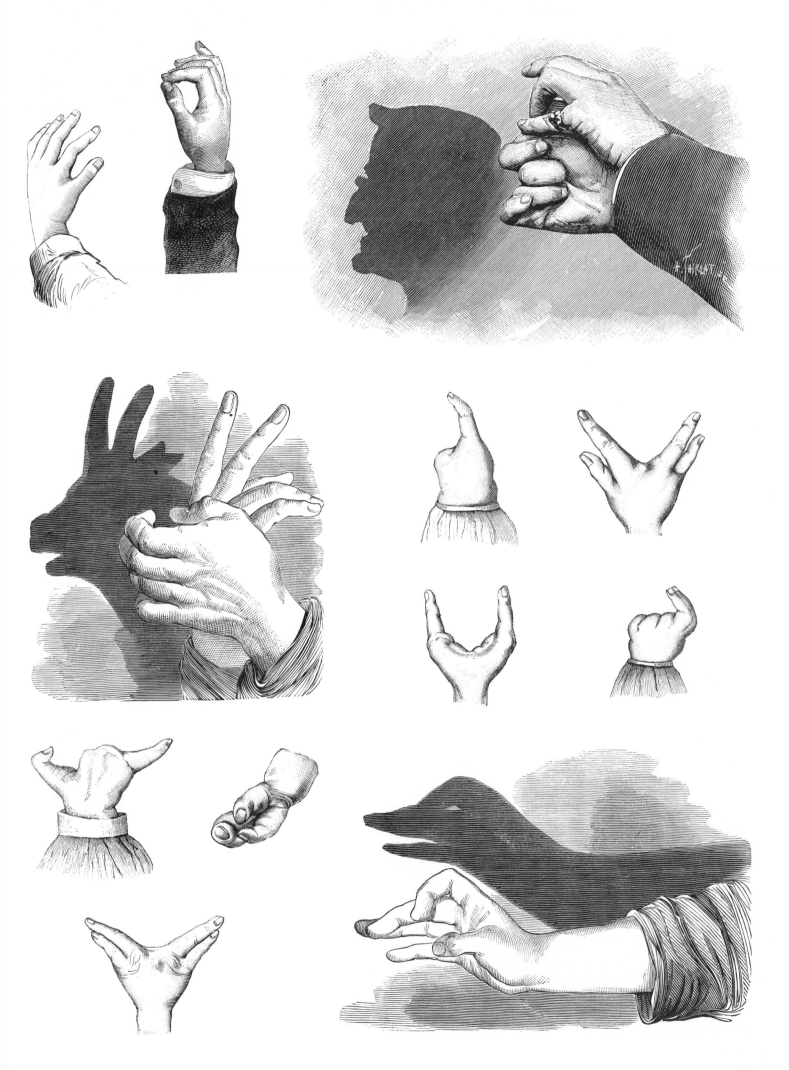

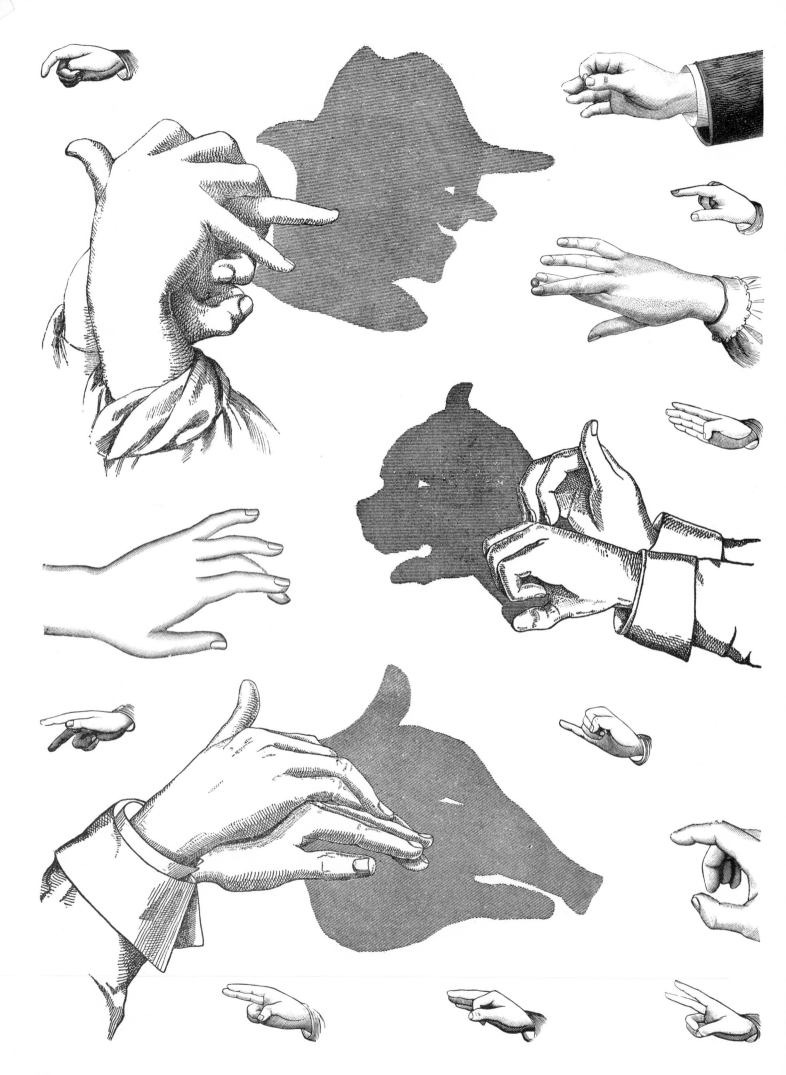

58

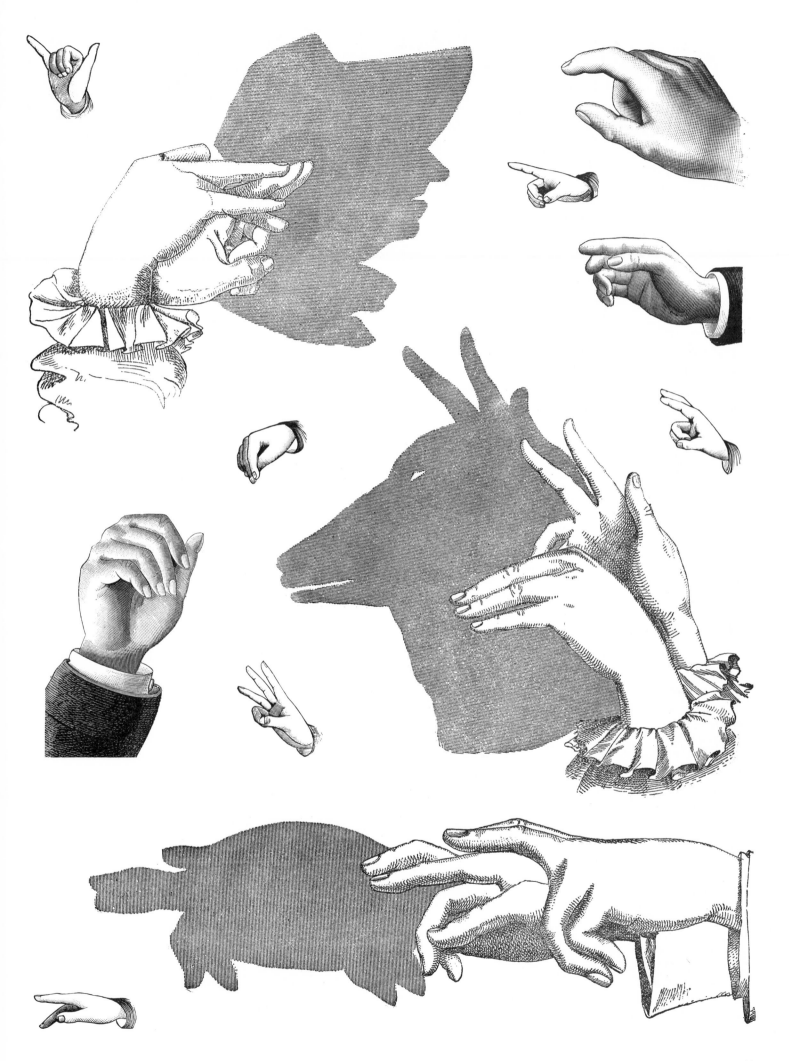

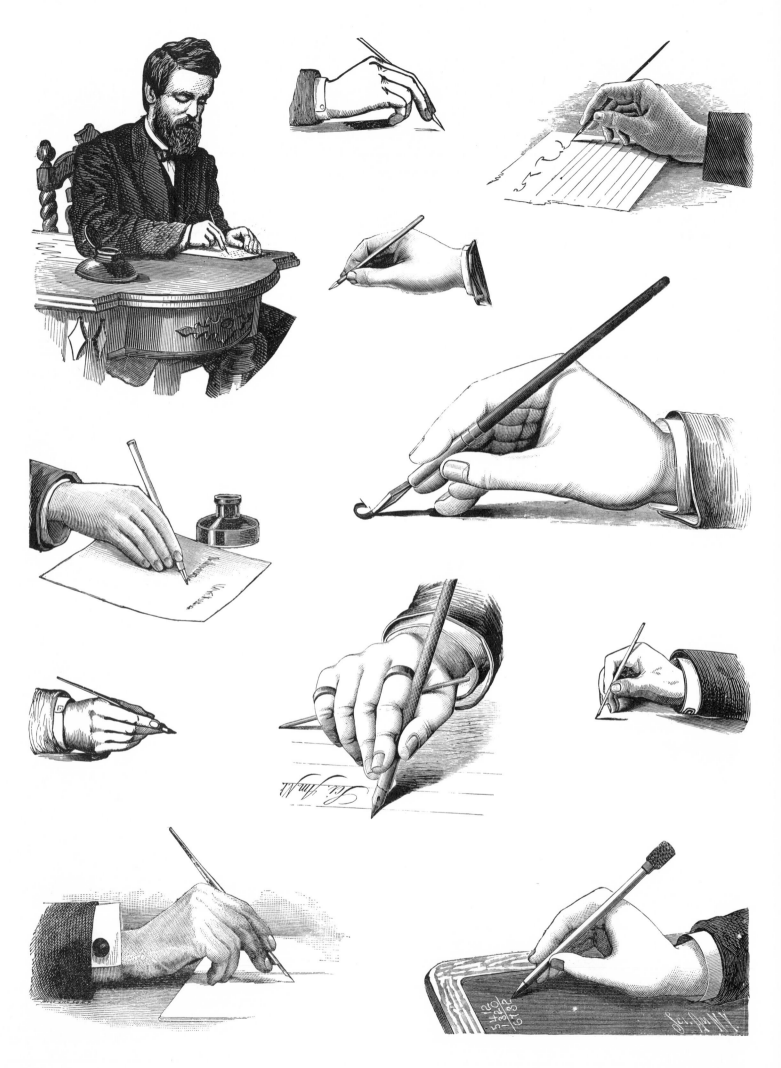

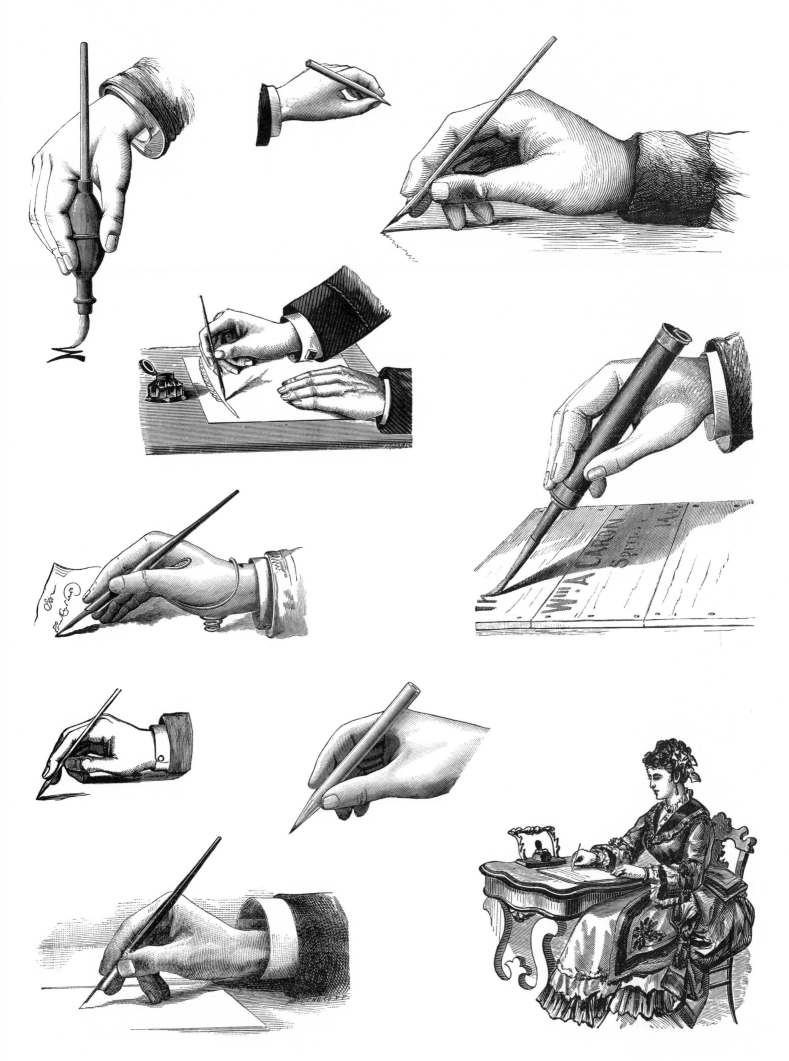

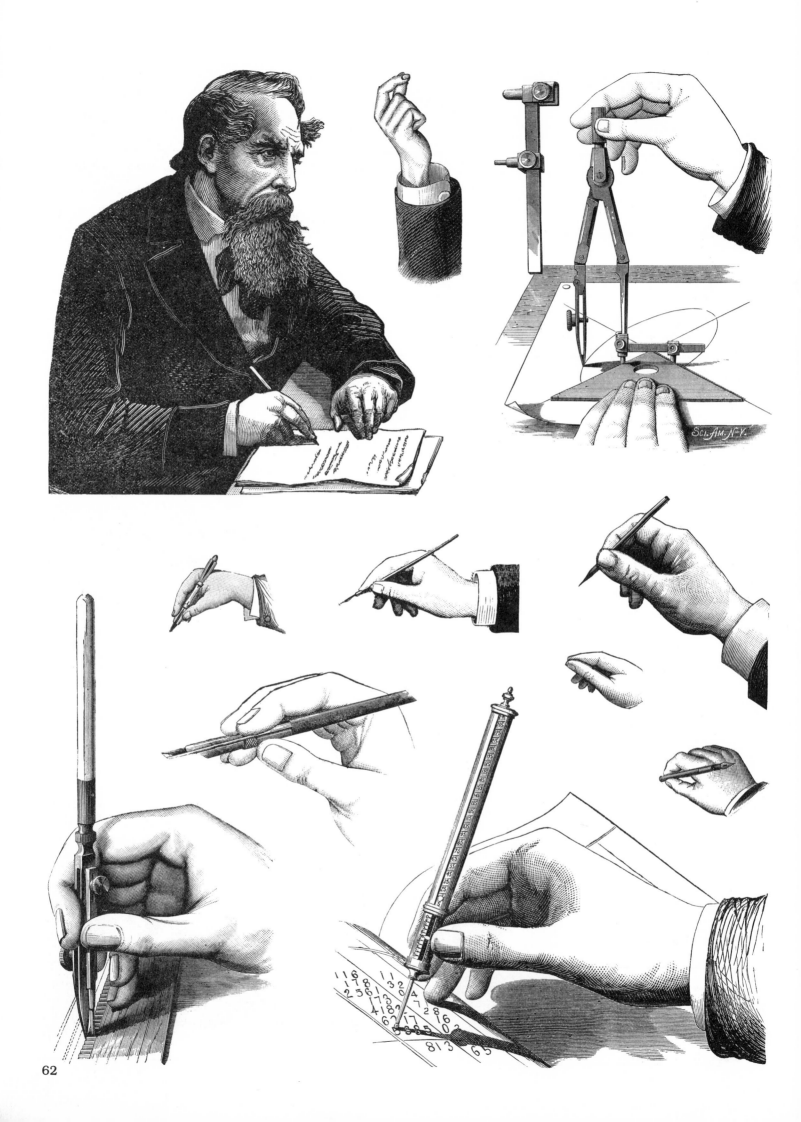

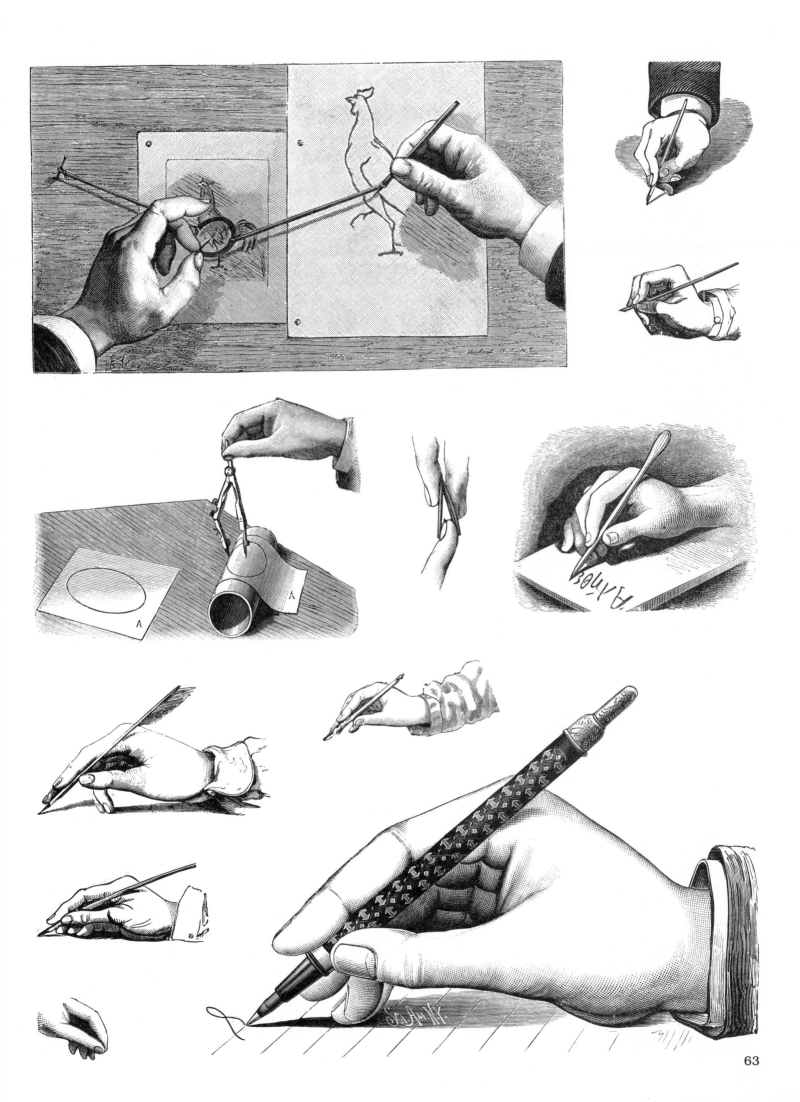

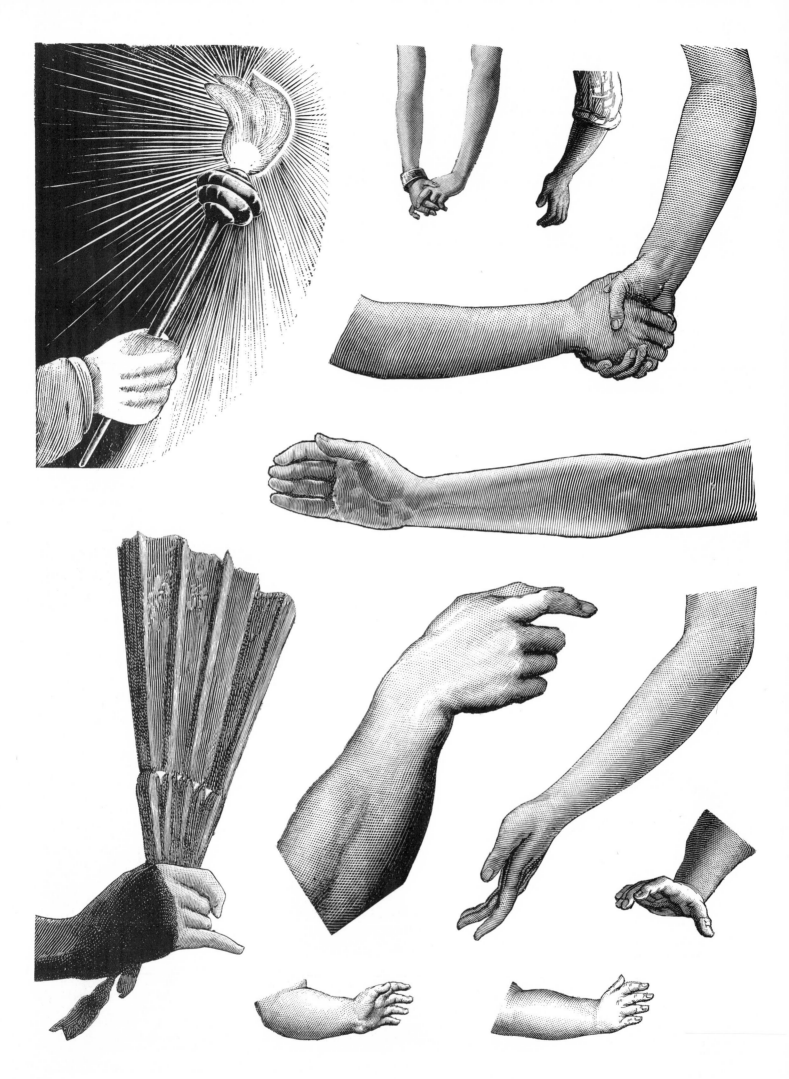

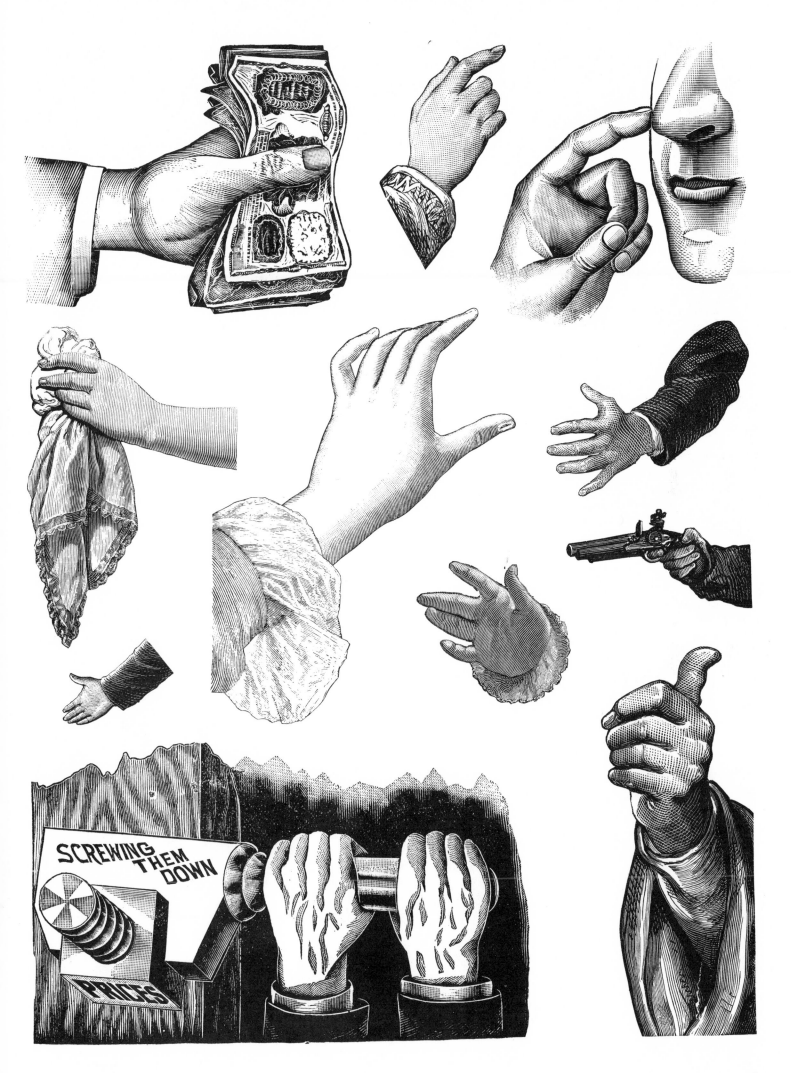

Über hundert Jahre
im Dienste der Reklame.

Glätti-Brunner
CLICHÉS
LÖWENSTR. 33 ZÜRICH TEL. 25 88 53/54

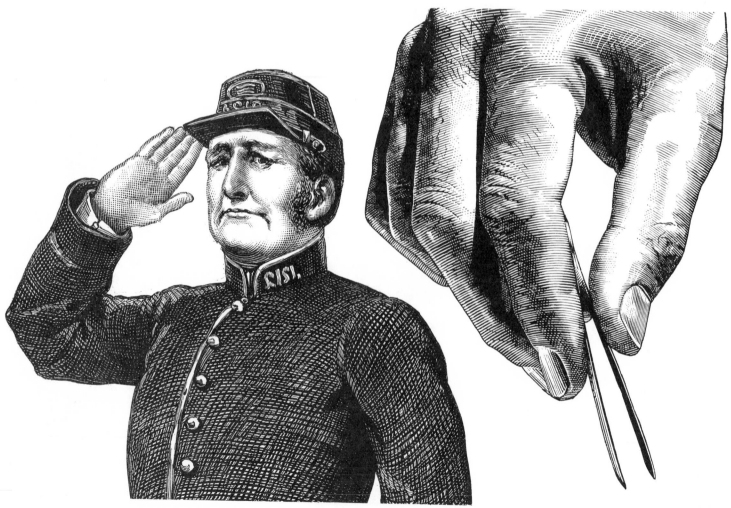

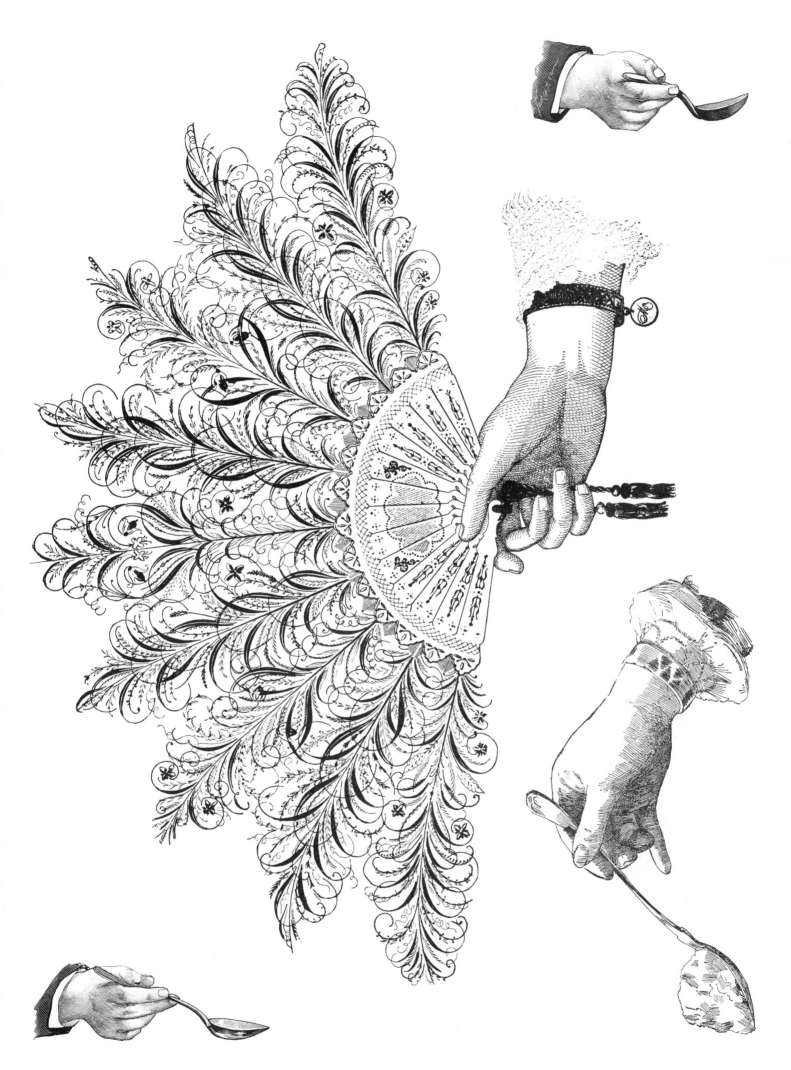

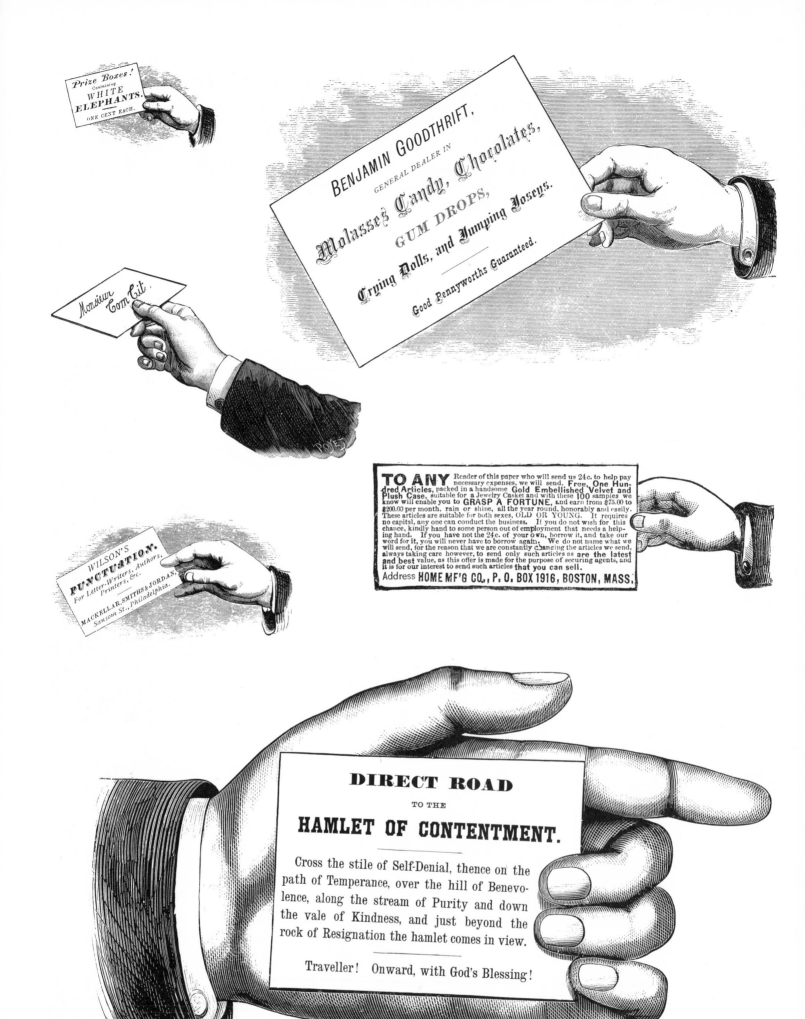

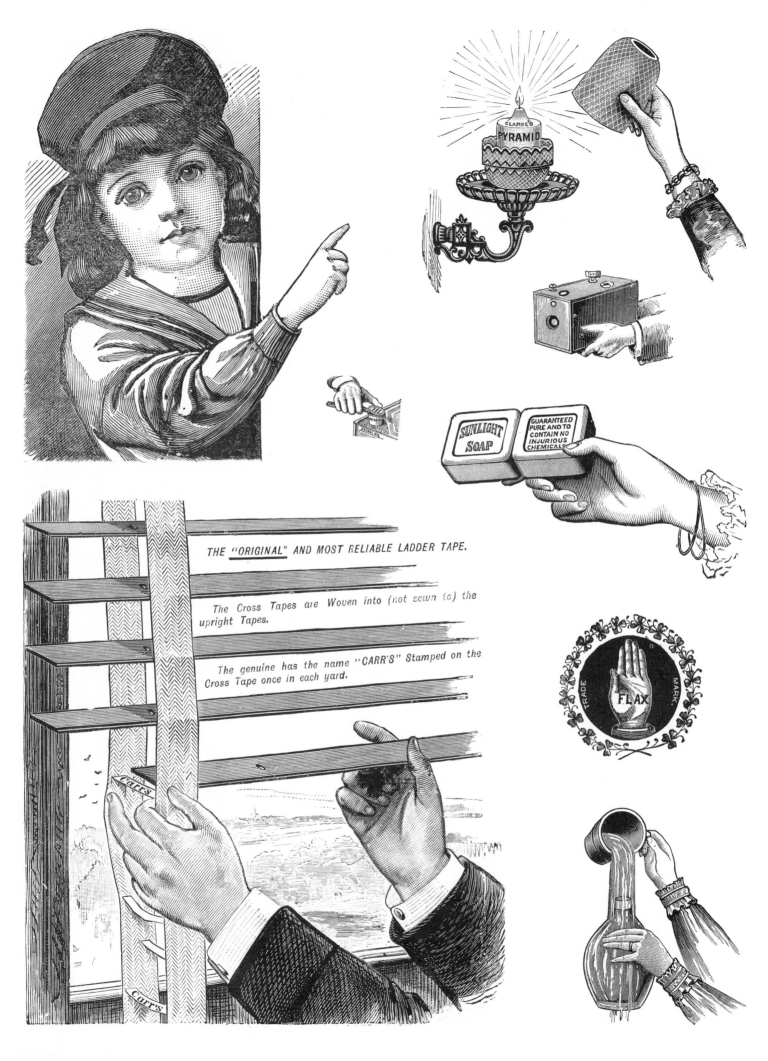

THE "ORIGINAL" AND MOST RELIABLE LADDER TAPE.

The Cross Tapes are Woven into (not sewn to) the upright Tapes.

The genuine has the name "CARR'S" Stamped on the Cross Tape once in each yard.

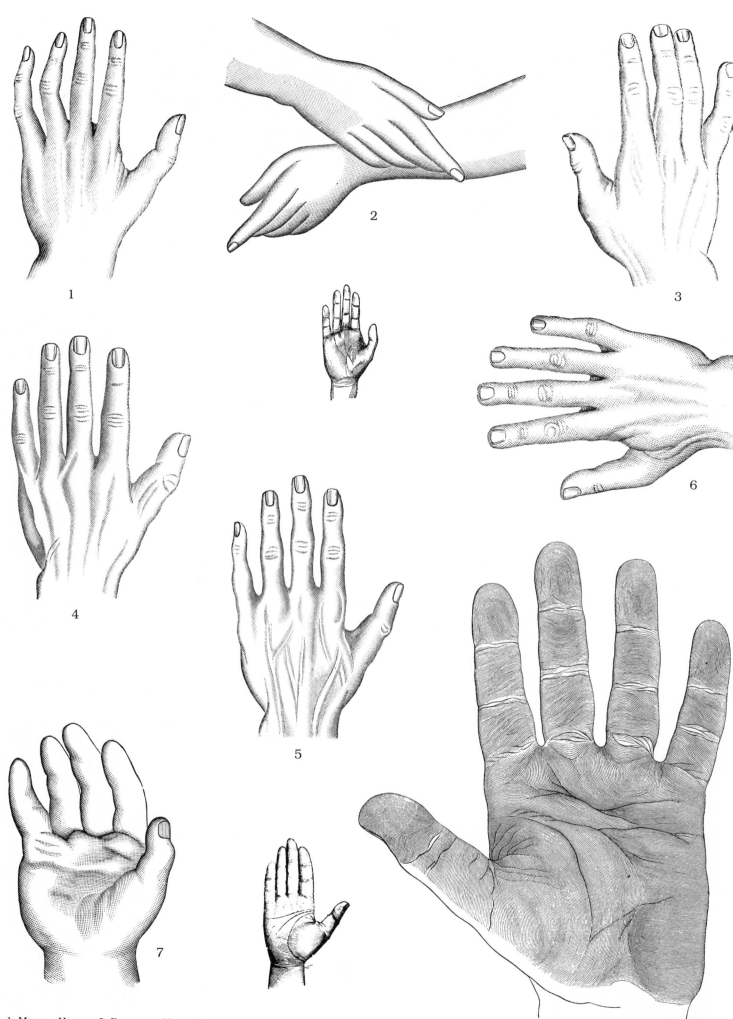

1. MENTAL HAND. 2. BEAUTIFUL HANDS (EMPRESS OF RUSSIA). 3. USEFUL HAND.
4. PHILOSOPHIC HAND. 5. SCIENTIFIC HAND. 6. SPATULATE HAND. 7. VEGETATIVE HAND.

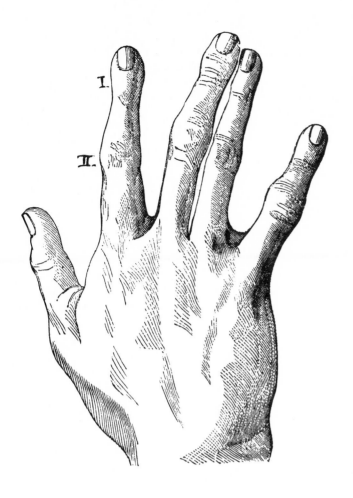

THE KNOTS.

I. Knot of the Philosopher.
II. Knot of Order in material things.

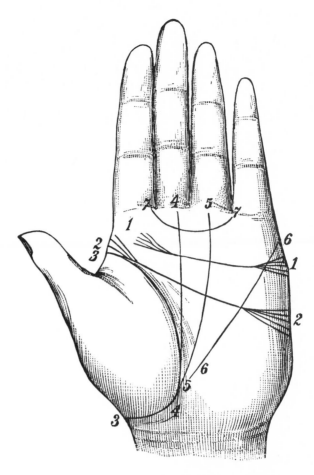

THE SEVEN PRINCIPAL LINES.

1. Line of Heart. 2. Line of Head. 3. Line of Life.
4. Line of Saturn. 5. Line of the Sun. 6. Line of the Liver.
7. Venus's Ring.

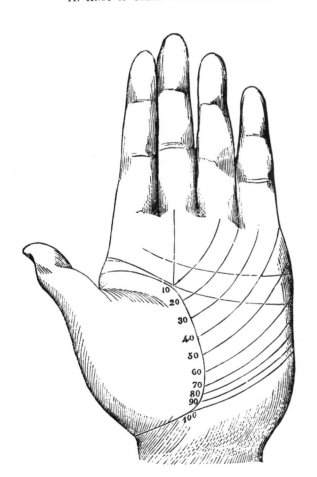

THE PERIODS OF LIFE IN THE HAND.

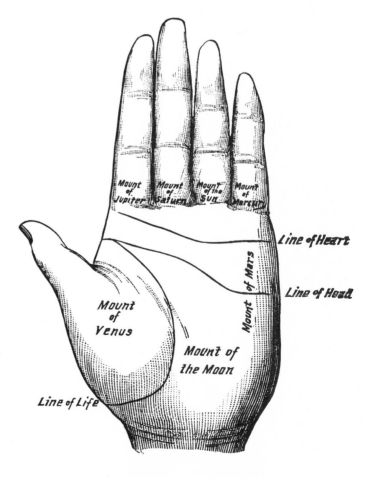

THE MOUNTS OF THE HAND.

73

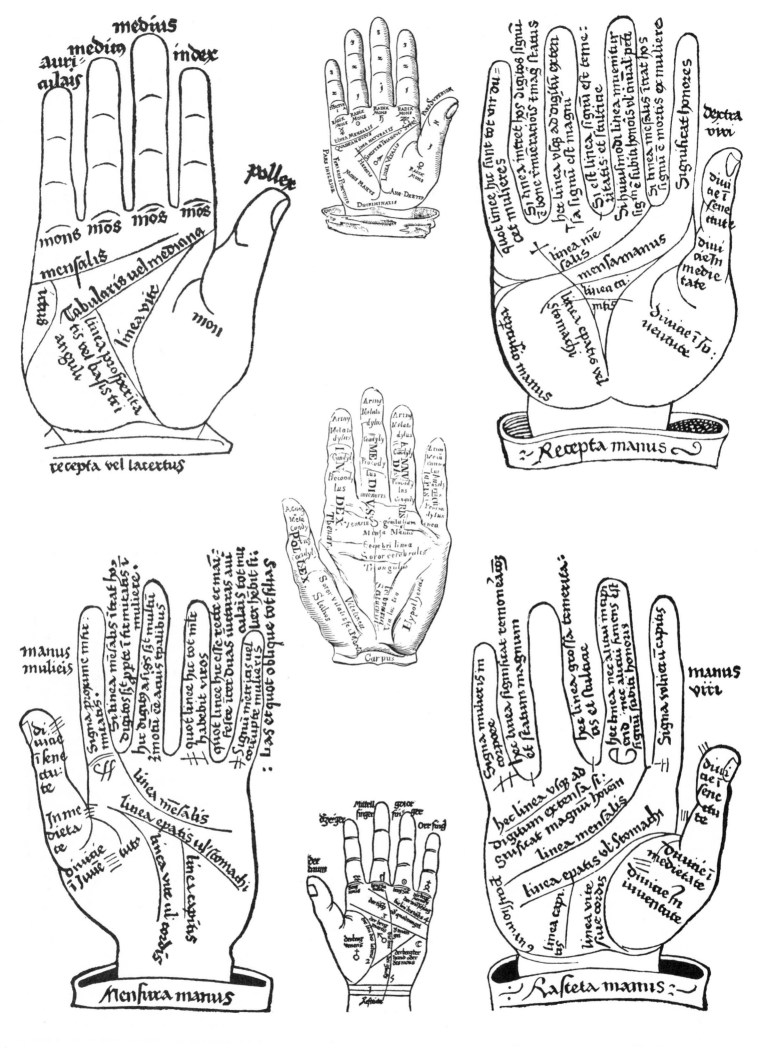

74

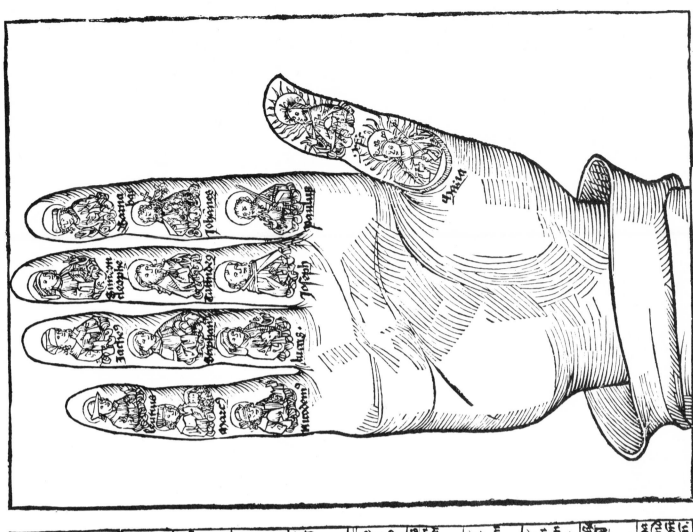

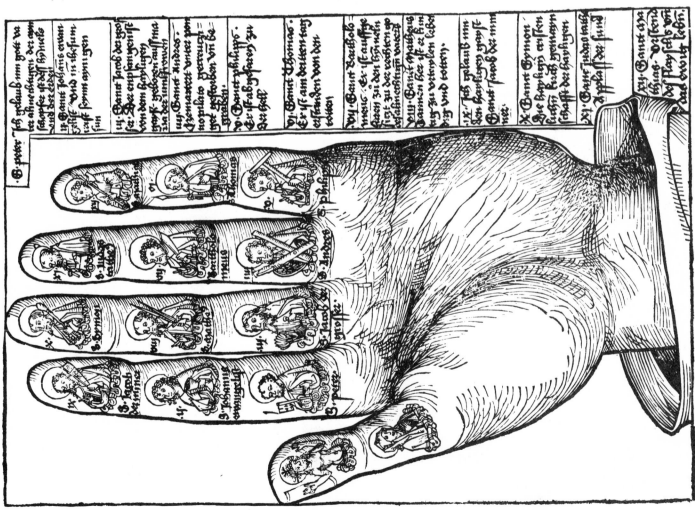

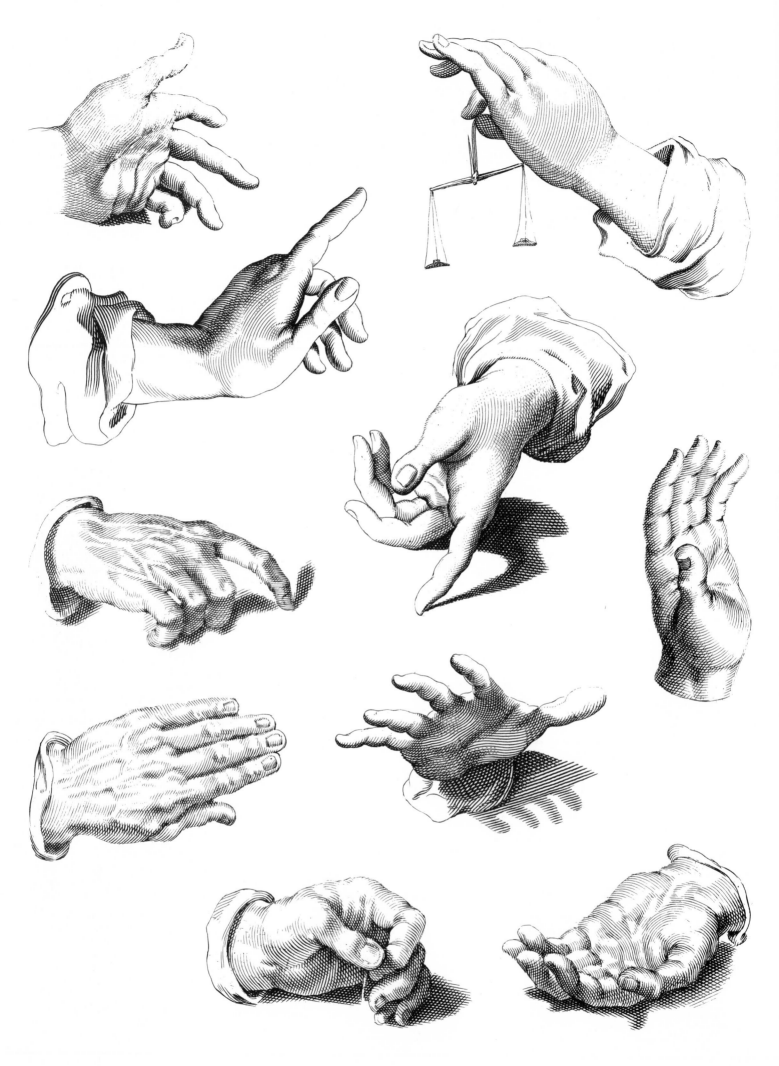

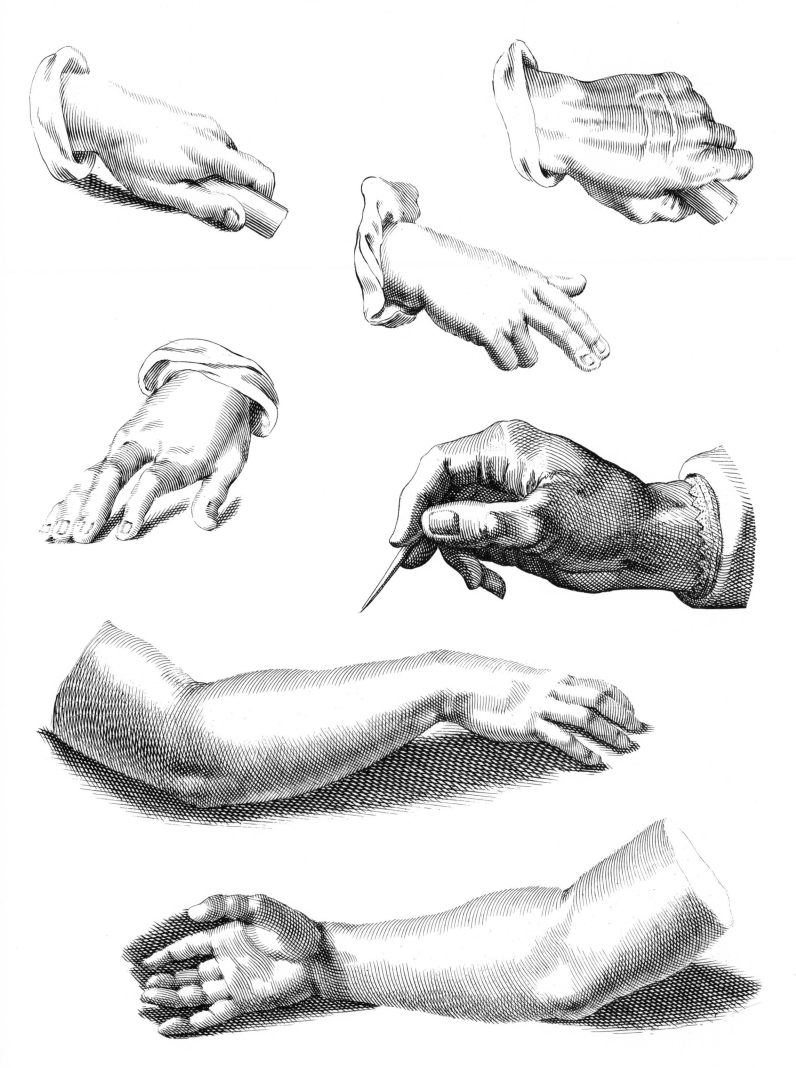

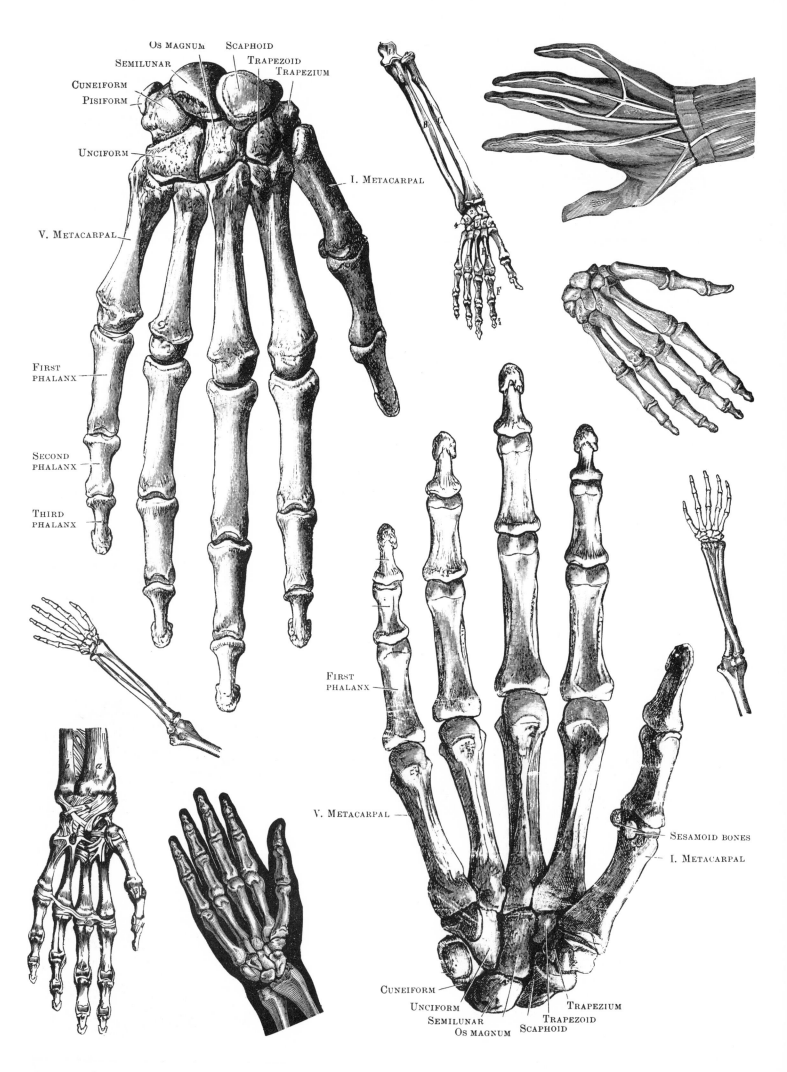

OS MAGNUM SCAPHOID

SEMILUNAR TRAPEZOID
TRAPEZIUM

CUNEIFORM
PISIFORM

UNCIFORM

I. METACARPAL

V. METACARPAL

FIRST
PHALANX

SECOND
PHALANX

THIRD
PHALANX

FIRST
PHALANX

V. METACARPAL

SESAMOID BONES

I. METACARPAL

CUNEIFORM

UNCIFORM TRAPEZIUM

SEMILUNAR TRAPEZOID

OS MAGNUM SCAPHOID

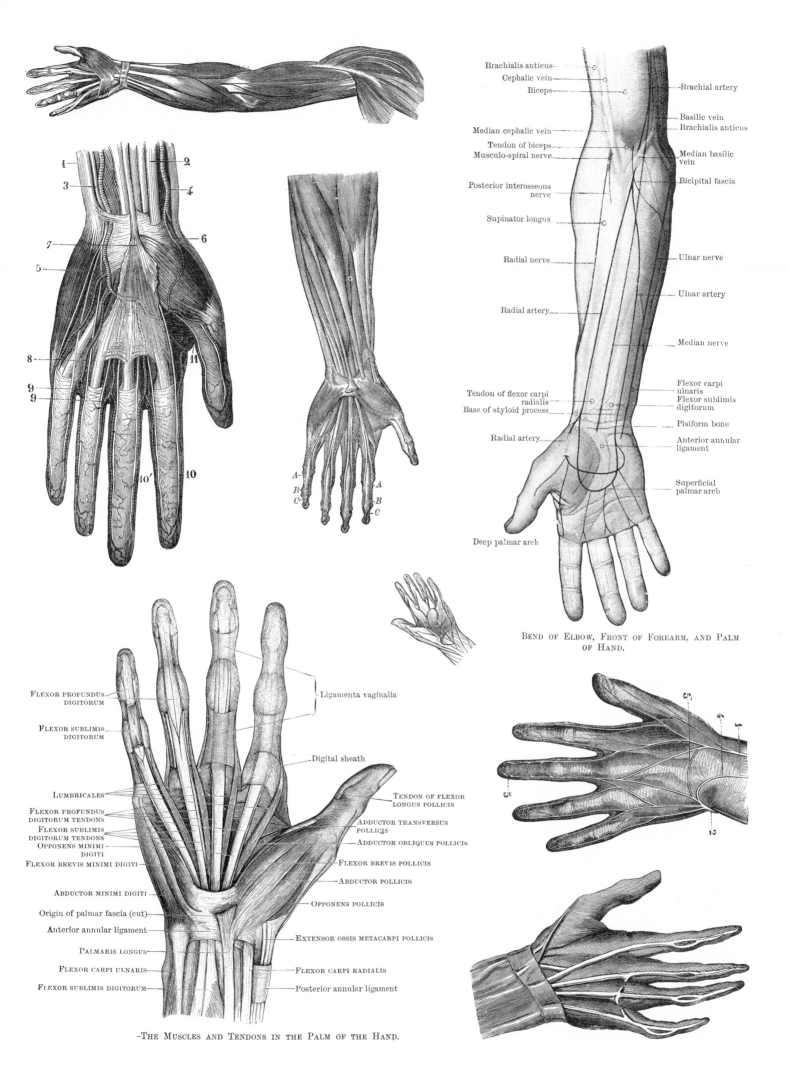

4
2
3
4
7
6
5
8
11
9
9
10′ 10

A
B
C
A
B
C

Brachialis anticus
Cephalic vein
Biceps
Brachial artery
Basilic vein
Brachialis anticus
Median cephalic vein
Tendon of biceps
Musculo-spiral nerve
Median basilic vein
Posterior interosseous nerve
Bicipital fascia
Supinator longus
Radial nerve
Ulnar nerve
Ulnar artery
Radial artery
Median nerve
Tendon of flexor carpi radialis
Base of styloid process
Flexor carpi ulnaris
Flexor sublimis digitorum
Pisiform bone
Radial artery
Anterior annular ligament
Superficial palmar arch
Deep palmar arch

Bend of Elbow, Front of Forearm, and Palm of Hand.

Flexor profundus digitorum
Flexor sublimis digitorum
Ligamenta vaginalia
Digital sheath
Lumbricales
Flexor profundus digitorum tendons
Flexor sublimis digitorum tendons
Opponens minimi digiti
Flexor brevis minimi digiti
Abductor minimi digiti
Origin of palmar fascia (cut)
Anterior annular ligament
Palmaris longus
Flexor carpi ulnaris
Flexor sublimis digitorum
Tendon of flexor longus pollicis
Adductor transversus pollicis
Adductor obliquus pollicis
Flexor brevis pollicis
Abductor pollicis
Opponens pollicis
Extensor ossis metacarpi pollicis
Flexor carpi radialis
Posterior annular ligament

—The Muscles and Tendons in the Palm of the Hand.

79

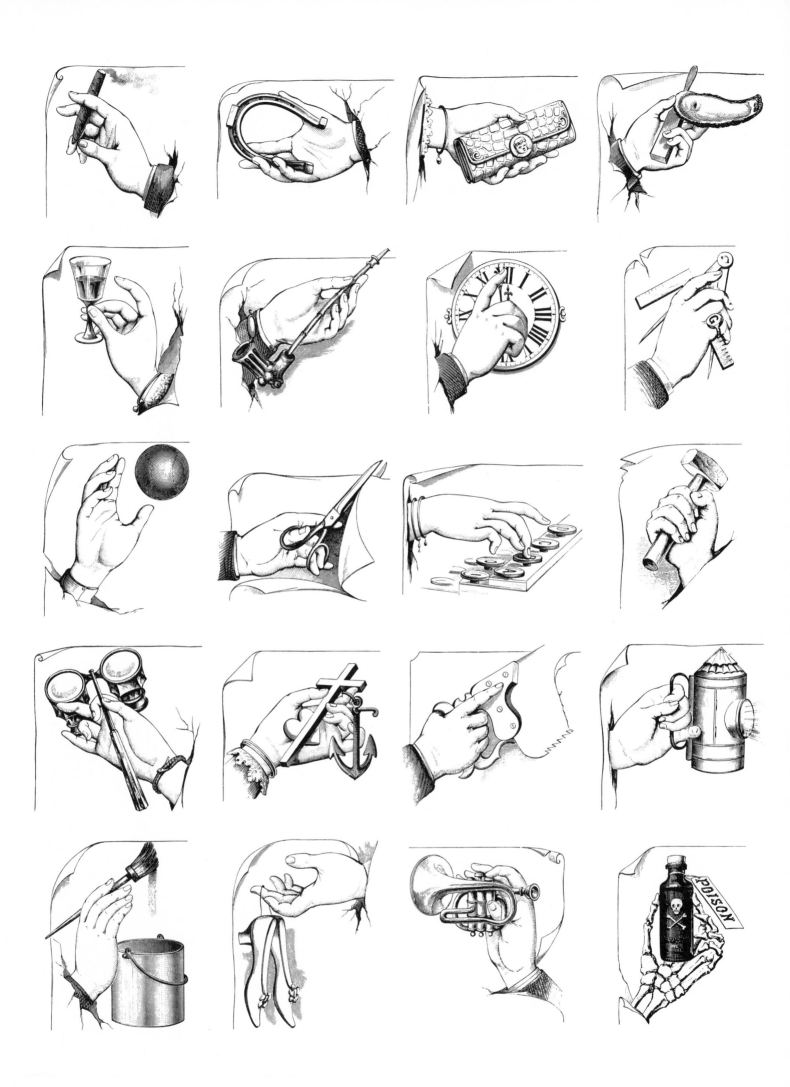

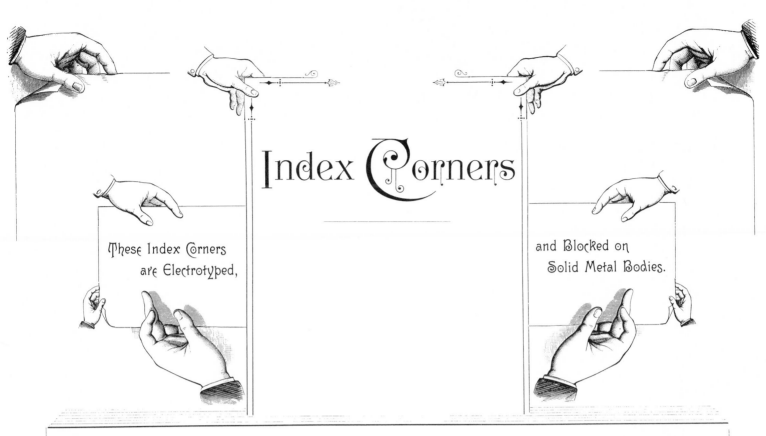

Index Corners

These Index Corners are Electrotyped, and Blocked on Solid Metal Bodies.

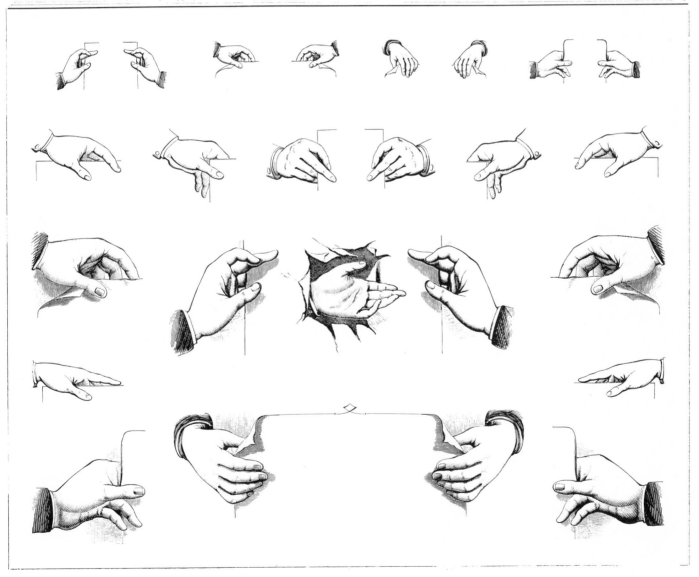

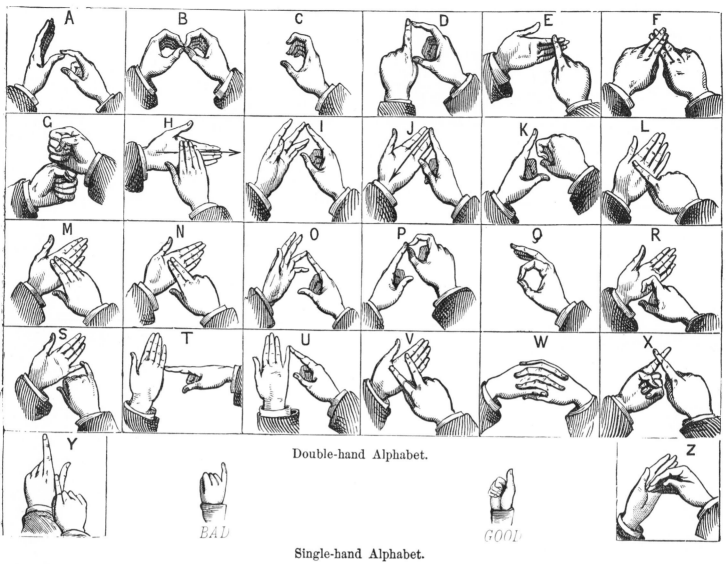

Double-hand Alphabet.

Single-hand Alphabet.

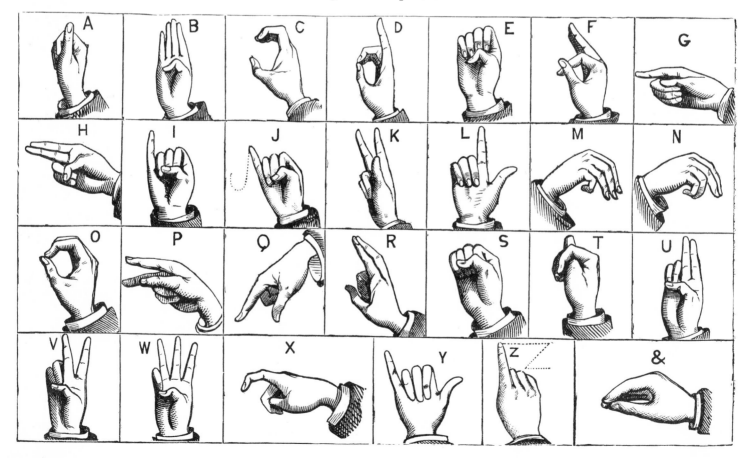

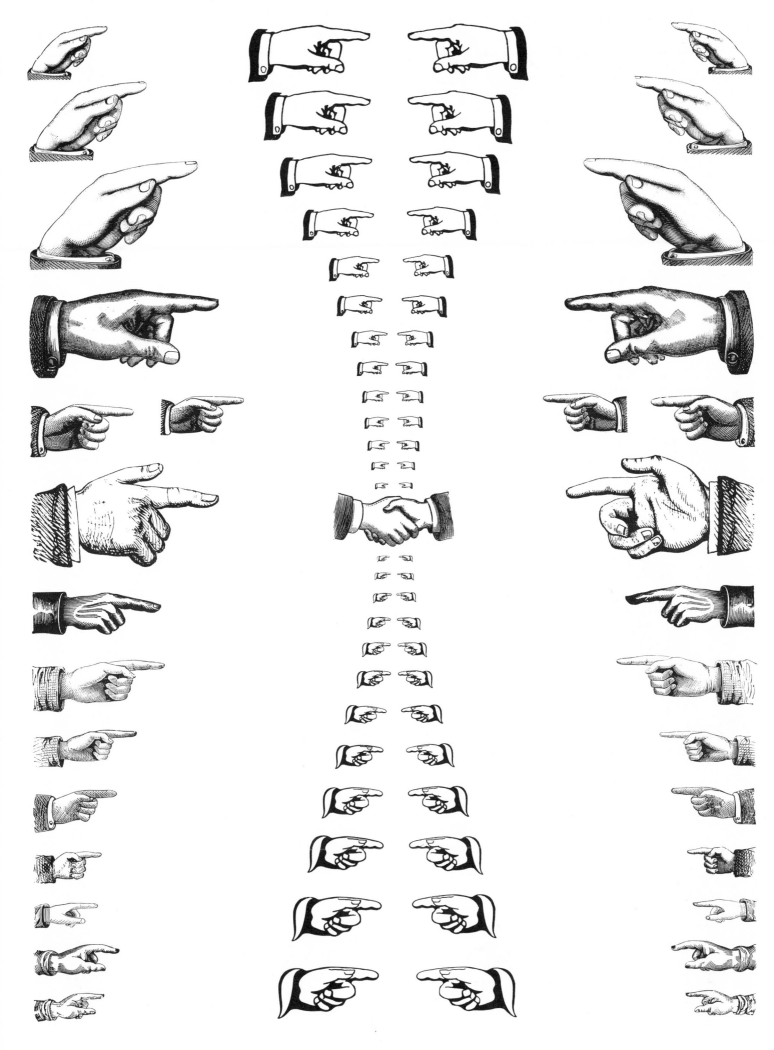

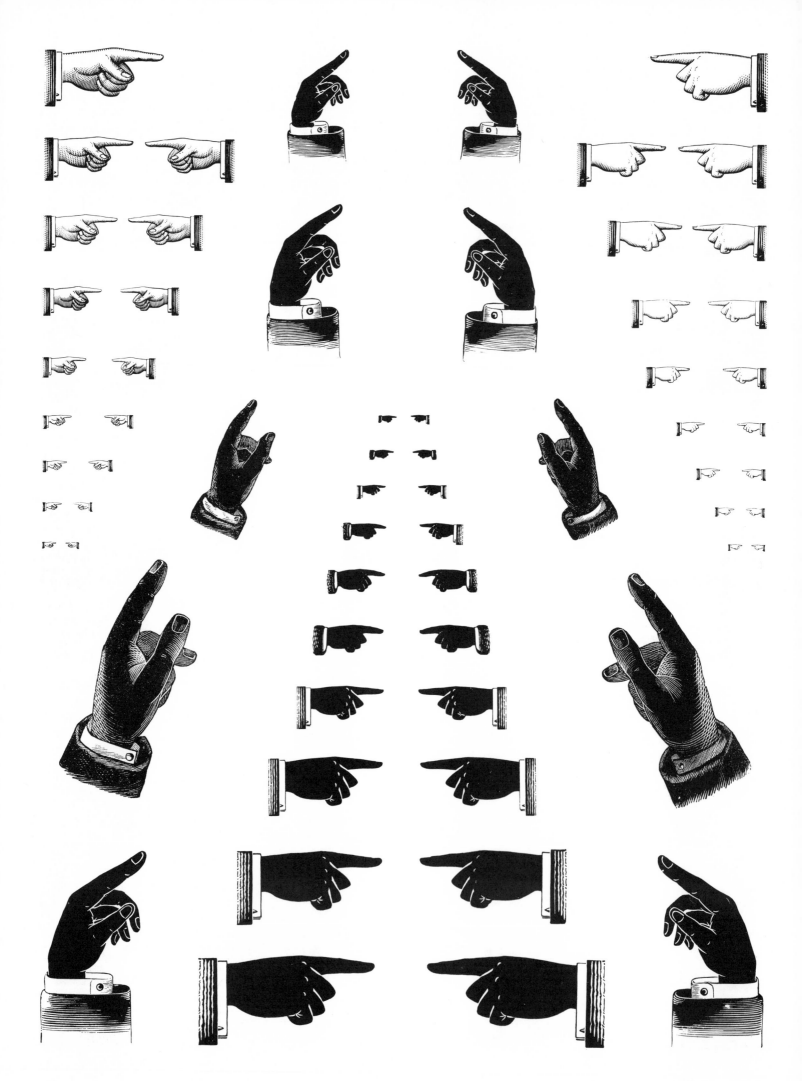

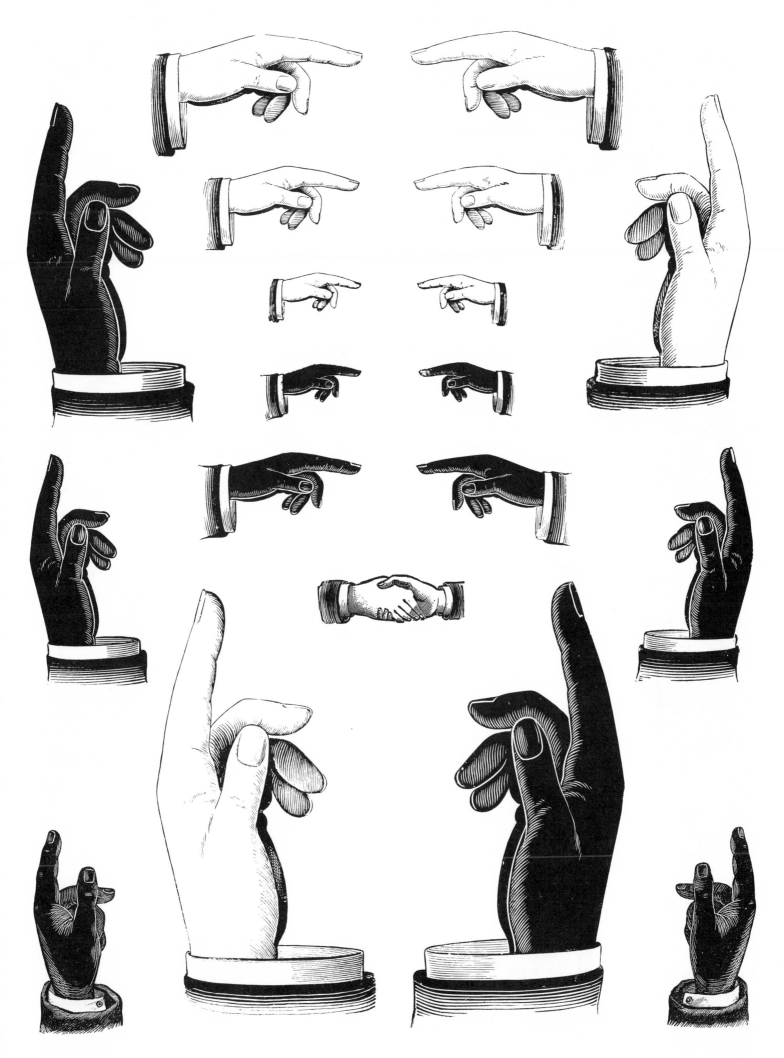

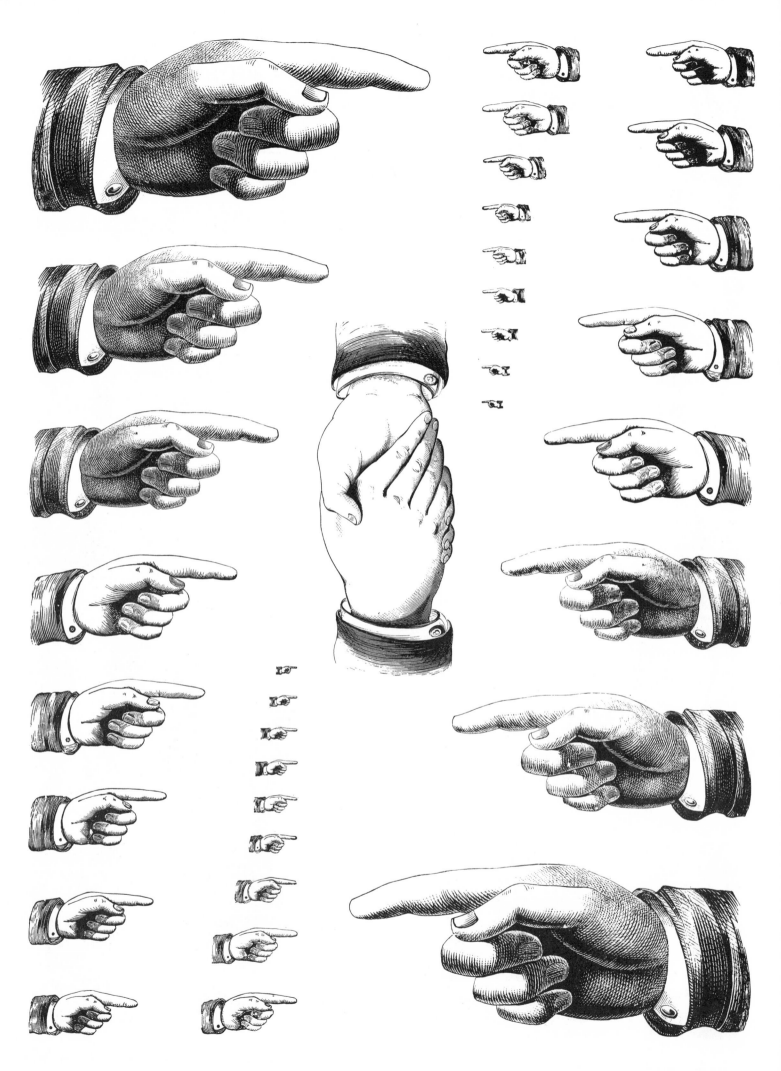

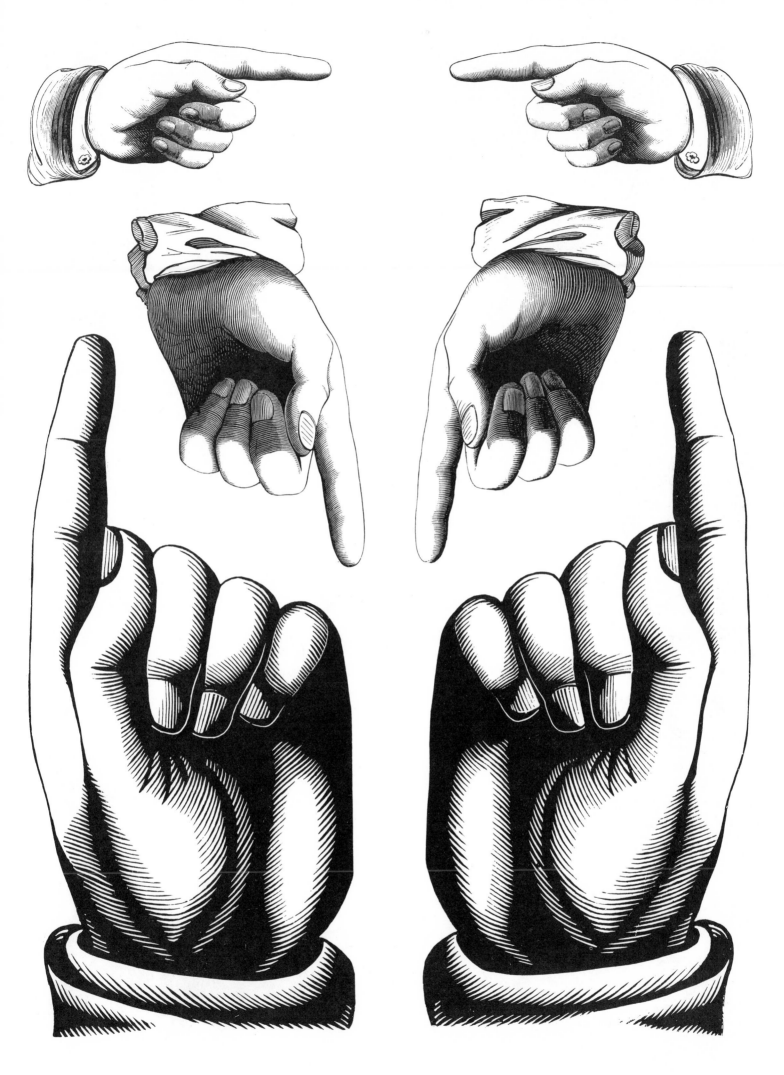

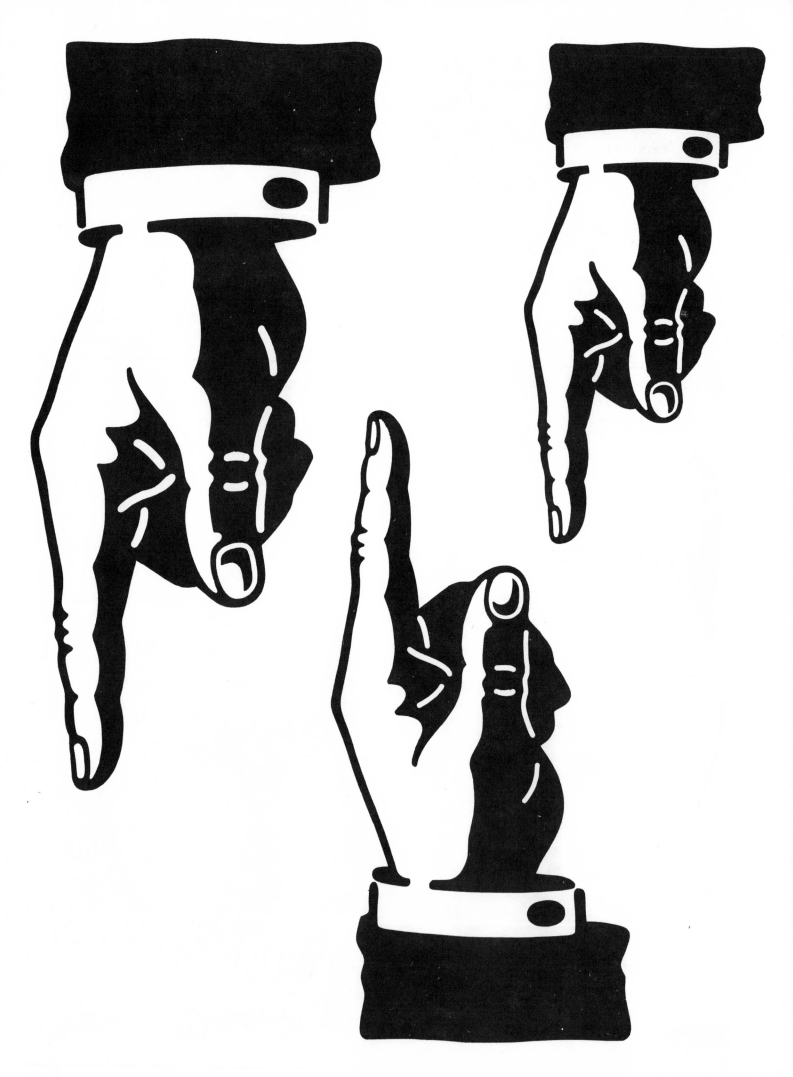

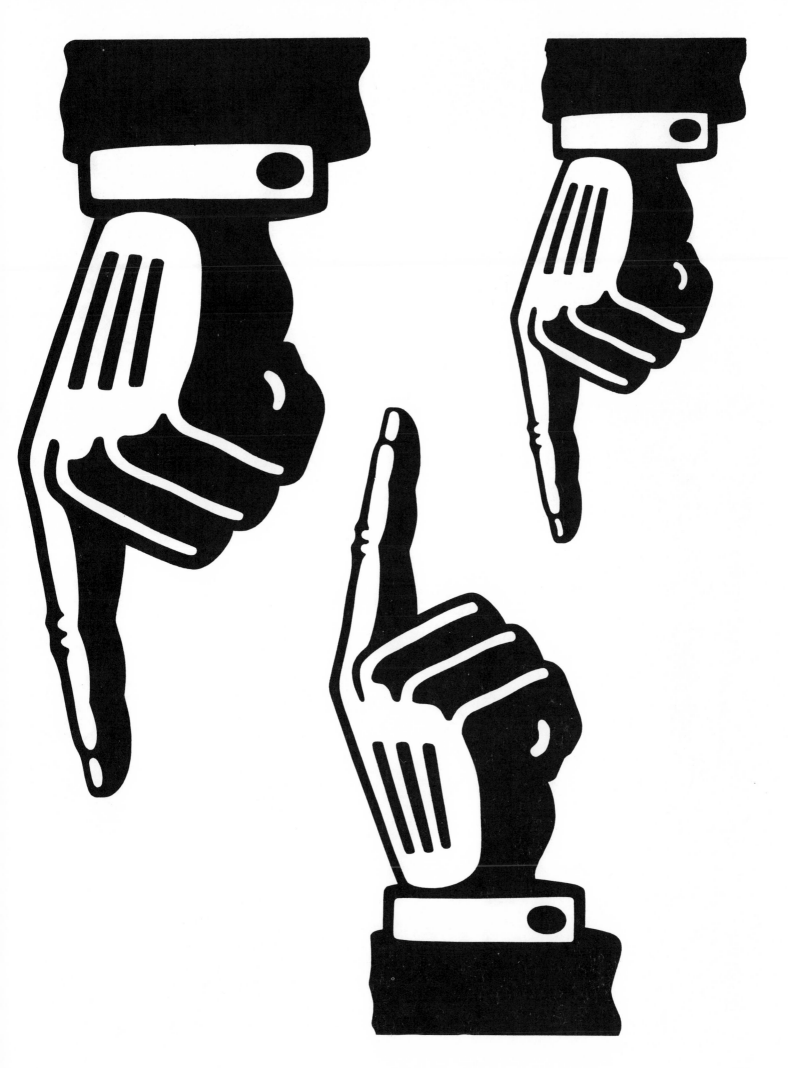

89

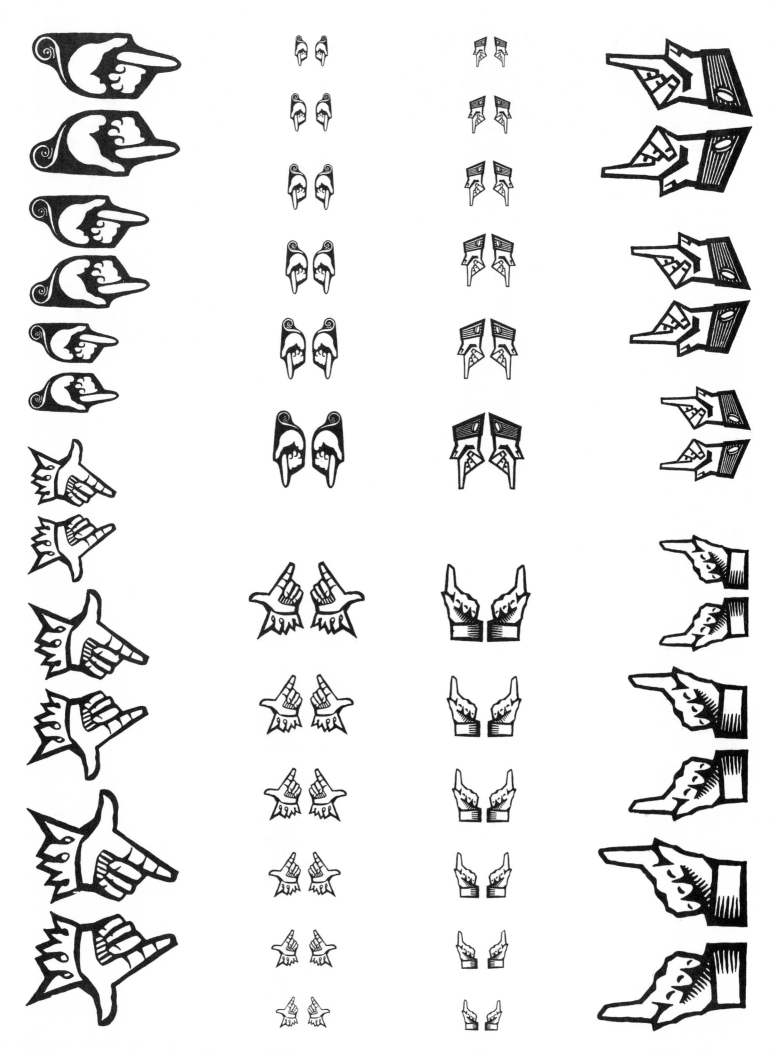